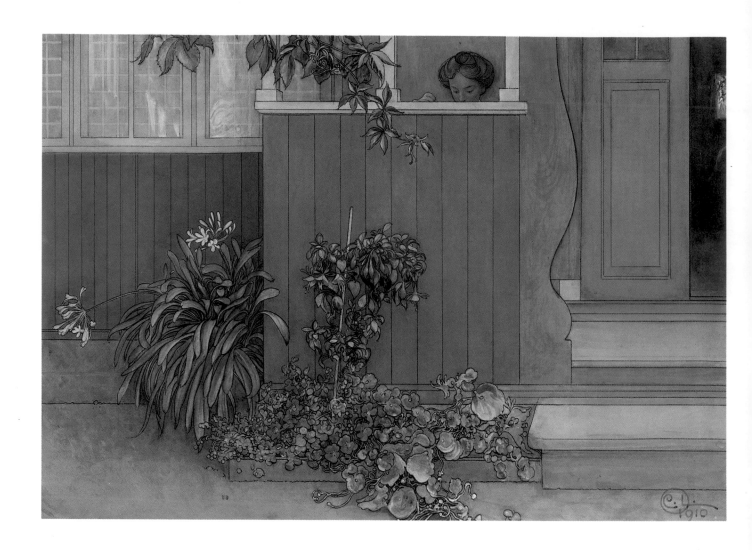

Carl Larsson

THE BROOKLYN MUSEUM METHUEN

Published for the exhibition
Carl Larsson
The Brooklyn Museum, New York
November 10, 1982—January 30, 1983

Front cover:
Carl Larsson
Suzanne and Another 1901
Suzanne och en ann'
Watercolor on paper
94.0 x 62.5 cm. (37 x 24⅝ in.)
[Private collection, Sweden]
Cat. no. 29

Frontispiece:
Carl Larsson
Suzanne on the Front Step 1910
Suzanne på förstubron
Watercolor on paper
63.0 x 98.0 cm. (20¾ x 38⅝ in.)
[Private collection, Sweden]
Cat. no. 47

Back cover:
Carl Larsson
The Studio *circa* 1895
Ateljén
Watercolor on paper
32.0 x 43.0 cm. (12⅝ x 17 in.)
Published in *Ett hem,* 1899
[Collection: Nationalmuseum,
Stockholm, Sweden]
Cat. no. 16

ISBN 0 416 44520 9

First published in Great Britain in 1983.
Made available to the trade by:
Methuen Children's Books Ltd
11 New Fetter Lane
London EC4P 4EE
by arrangement with
Holt, Rinehart and Winston, New York.

Designed and published by The
Brooklyn Museum, Division of
Publications and Marketing Services,
Eastern Parkway, Brooklyn, New York
11238. Printed in the USA by Zarett
Graphics Corp., New York.

*Carl Larsson was organized by The Brooklyn
Museum and the Nationalmuseum in Stockholm
with the support of the Swedish Institute in
Stockholm.*

*Carl Larsson has been made possible by a grant
from the Samuel J. and Ethel Lefrak Foundation
and is a project of Scandinavia Today, an American
celebration of contemporary Scandinavian culture
sponsored and administered by the American-
Scandinavian Foundation and made possible by
support from Volvo, Atlantic Richfield Company, the
National Endowment for the Humanities, and the
National Endowment for the Arts.*

*Scandinavia Today was organized with the
cooperation of the Governments of Denmark,
Finland, Iceland, Norway, and Sweden through the
Secretariat for Nordic Cultural Cooperation and
with the aid of a grant from the Nordic Council of
Ministers.*

Cat. no. 93

Contents

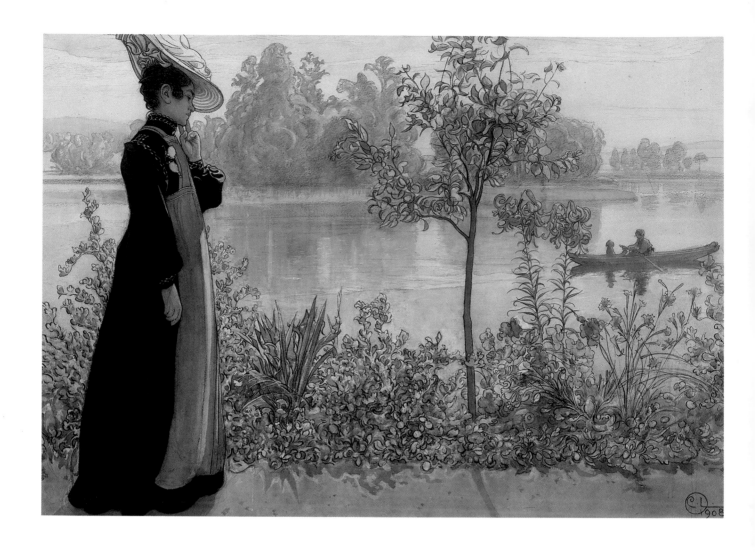

Carl Larsson
The End of Summer (Karin by the Shore) 1908
Efter sommer (Karin vid strand)
Watercolor on paper
52.6 x 74.5 cm. (20¾ x 29⅜ in.)
Published in *Åt solsidan,* 1910
[Collection: The Malmö Museum, Sweden]
Cat. no. 38

Karin is shown wearing the big hat that Larsson liked to use as a decorative object and is standing in a meditative pose by the side of the river in front of the Sundborn house. Larsson characteristically notes the detail of the embroidery on her dress and the glasses pinned to her cloth. Though he always depicted Karin with the features of a young woman, she was by now nearing fifty. As in most of the Åt solsidan *paintings, the figure is larger in relation to the field than in the* Ett hem *series. But Larsson continues to compose—in an outdoor setting like this one as well as in the interiors—with a clear-cut rectilinear structure of horizontal bands and strong vertical elements.*

Foreword

Michael Botwinick

Director,
The Brooklyn
Museum,
New York

With this exhibition, The Brooklyn Museum is pleased to introduce to an American audience an important turn-of-the-century Swedish artist whose decorative art and pictorial imagery have given delight to generations of people in Northern Europe. Carl Larsson was a leading member of the progressive generation of Swedish artists who sought to bring fresh life to the art of their homeland in the 1880s and '90s. Although his gifts as a mural designer led to important public commissions in Sweden, he is best known and loved for the special quality of the paintings he made—mostly in watercolor, a medium of which he was a master—of the life of his family in and around their country house in the village of Sundborn. This house, which he and his artist wife Karin designed together, stands today as an early example of the Arts and Crafts style in cottage architecture and interior design. The central source of Larsson's inspiration was the theme of domesticity, through which he developed his distinctive style as "the illustrator of his own life," and it is this domestic pictorial world which forms the core of the present exhibition.

This project is due first and foremost to Sarah Faunce, Curator of Paintings and Sculpture at The Brooklyn Museum, who took it on in the midst of many other pressing responsibilities. We are most grateful to the Nationalmuseum in Stockholm for its enthusiastic collaboration on the project as well as for its generous loans. Director Per Bjurström and Chief Curator of Paintings Pontus Grate have supported the plan from the beginning, and Curator Görel Cavalli-Björkman has worked with Sarah Faunce on all aspects of organizing the exhibition. With few exceptions the works come to us from Scandinavia, and Mrs. Cavalli-Björkman has arranged for all of these loans, as well as contributing an essay and documentary information to the catalogue. Bo Lindwall, former Director of Prince Eugen's Waldemarsudde in Stockholm, and Björn Fredlund, Director of the Gothenburg Art Gallery, were helpful early advisors. We are grateful to the Swedish Institute in Stockholm for its essential support in funding all packing and transportation costs and the curatorial costs in Sweden; and to Birgitta Lönnell and Claes Sweger of the Swedish Information Service in New York City for their continuing assistance. Special thanks must of course go to all of the lenders, both institutional and private, who have allowed their works—in particular their light-sensitive watercolors—to come to the exhibition. We also wish to thank Mr. Arthur Altschul, the New York collector who in addition to lending his pictures has made available for our research Swedish publications otherwise difficult to consult here.

We are grateful to the Samuel J. and Ethel Lefrak Foundation for a grant that helped make this exhibition possible. Carl Larsson is a part of *Scandinavia Today*, which is administered by the American Scandinavian Foundation. We are grateful to Volvo and the Atlantic Richfield Company, and to the National Endowment for the Humanities and the National Endowment for the Arts, for their national sponsorship of *Scandinavia Today*. We also thank the interior design firm of Denning and Fourcade, Inc., for making it possible to include in the exhibition a "period room" in the Larsson style.

The Domestic Art of Carl Larsson

Sarah Faunce

Curator of
Paintings and
Sculpture,
The Brooklyn
Museum,
New York

Anyone who visits the Carl Larsson house in the Swedish village of Sundborn, having been attracted to the place by the delightful watercolors the artist made there in the years before and after 1900, will easily understand why Larsson has become something of a national institution. The little house with its barn-red or stuccoed walls and patterned trim, set in a cottage garden by the edge of a river bordered by birches, at one end of a village of red and white houses and apple trees, is a genuine pastoral idyll on an immediately accessible scale. Inside the house, an infectious simplicity unfolds: each room has its distinctive flavor, and each wall translates immediately into a pictorial surface composed of the patterns made by precisely placed doors, windows, shelves, pictures, and painted decorations. These interiors are composed with the same decorative sensibility that informs the paintings which record them and the family life which took place in them and outside in the garden, under the trees. By means of the paintings—which were published as well as exhibited—this sensibility, which was very much of its own period, became in time a popular ideal. To the visual charm of Larsson's imagery was added the moral appeal of an ideal domestic life that was described by the artist in the texts of his picture books. Impelled by the desire, also characteristic of his time, to both "serve" and "gladden" a wide public, he set forth as a model his own family life, which was lived in sophisticated rural simplicity, filled with children, and presided over by the perfect wife and mother. By thus encouraging the identity of life and work, he has in recent times become open to criticism both for the patriarchal nature of his ideal and for the discrepancy between the idyllic myth and the human reality. His very popularity in Sweden makes this controversy inevitable and indeed useful in establishing a fuller insight into the artist's personality.

Outside of Sweden, however, Larsson's domestic art may be taken without the burdens attached to a popular national figure, and his pictorial world may be enjoyed as a delightful example of the art of decorative illustration in a period when that art had achieved a rare degree of quality. One need not make an arbitrary divorce between the formal qualities of the pictures and their domestic subject matter in order to see them at once in their historical setting and as images of great charm in the present. The charm, for all those who feel it, is self-evident, and may for individual viewers have as much to do with their private recollections of the classic nursery books and happy country summers of childhood as with pictorial qualities. But it is the elements that Larsson took from among his aesthetic alternatives in the 1880s and '90s and that formed his own decorative and pictorial sensibility that this essay will briefly explore.

When Larsson went to Grèz-sur-Loing outside Paris in 1882 to join its community of Scandinavian, English, and American artists, he was an unhappy man of twenty-nine who had been a successful illustrator since youth but had failed as a painter in an outdated Romantic style. When he left France to return to Sweden in 1885 he was not only a happy man, married to a fellow artist and the father of a first child—a biographical fact which in his case is not incidental to his career as an artist—but he had also joined the cosmopolitan modern world and laid the foundation for what he would become in the future. In his essay "Nationalism, Internationalism, and the Progress of Scandinavian Art" (*Northern Light: Realism and Symbolism in Scandinavian Painting, 1880-1910,* The Brooklyn Museum, 1982) Kirk Varnedoe has lucidly analysed the forces which attracted Scandinavian artists to Paris around 1880, their responses to the late Realist style prevailing there, and the way in which the imperatives of Realism itself helped to lead them back to their native lands. Larsson, though his capacities and instincts lay rather in the direction of narrative/decorative art than of painting *per se,* was moved by the same ideas and images as were his fellow painters, and during his three years in Grèz he established himself as a member of the progressive group of Nordic artists whose ambition it became

Cat. no. 88

Carl Larsson
By the River Loing at Grèz 1887
Vid Loing, Grèz
Watercolor on paper
45.0 x 65.0 cm. (17¾ x 25⅝ in.)
[Private collection, Sweden]
Cat. no. 7

*By 1887, Larsson had established close ties with the
Gothenburg patron Pontus Fürstenberg, whose collection of
contemporary Swedish painting (now in the Gothenburg Art
Gallery) was to become one of the most important collections of
turn-of-the-century Swedish art. (See Tone Skedsmo,
"Patronage and Patrimony" in* Northern Light: Realism and
Symbolism in Scandinavian Painting, 1880-1910, *The
Brooklyn Museum, 1982). Fürstenberg not only bought
paintings but also established friendships with the artists of his
choice, helping them to acquire positions and commissions. He
got Larsson a teaching job at the Gothenburg Museum's
Printing and Drawing School in 1886 and commissioned him
to paint a large triptych on the theme of Renaissance, Rococo,
and Modern Art for the walls of his gallery in 1888. In the
spring of 1887 Larsson travelled to Paris with Fürstenberg and
visited Grèz, where he painted this watercolor. His friend and
fellow Swedish painter Bruno Liljefors was there on his
honeymoon, and Anna Liljefors is the figure looking out of the
boathouse. This work reveals Larsson's mastery of watercolor
in painting a Naturalist depiction of a* plein-air *motif.*

Facing page:
Carl Larsson
Autumn 1884
Höst
Watercolor on paper
92.0 x 60.0 cm. (36¼ x 23⅝ in.)
[Collection: Nationalmuseum,
Stockholm, Sweden]
Cat. no. 3

*In 1884 Larsson followed up his Salon success of the previous
year (see p. 26) with the submission of a watercolor called* The
Dam, *which was bought for the Luxembourg Gallery in Paris,
together with other watercolors like this one, of single figures
in an intimate landscape setting. In* Autumn, *with its silvery
tones and its sharply focused figure set behind a large
foreground mass of open, visually flattened space, the specific
influence of Jules Bastien-Lepage is apparent. It was
characteristic of Larsson that his favored subjects included not
only the local farm folk of Grèz but also such a young and
pretty woman as this nursemaid who looked after
Larsson's first child Suzanne, and who is dressed—as she is in*
The Old Wall *(cat. no. 4)—in an eighteenth-century costume
not connected with her everyday work. A further dramatic note
is provided by the envelope and torn letter which lie on the
ground.*

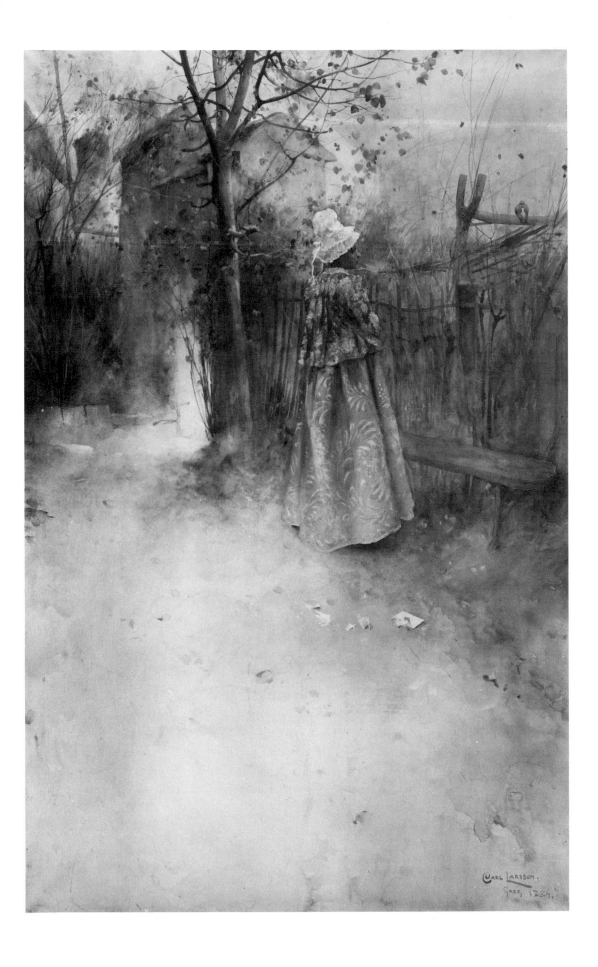

11

to challenge the academic art establishments of their homelands and to make an art that would be both new and rooted in national feeling.

After his first tentative essays in *plein-air* painting, Larsson found in the medium of watercolor the instrument with which he could best come to terms with the Naturalist vision. Like his colleagues, he saw the pictorial flatness that was paradoxically inherent in the Naturalism of Jules Bastien-Lepage and developed it in his Grèz watercolors of figures in village gardens (see pp. 10, 11, and 26). In these paintings can be seen as well his attraction to the pretty costume pictures done in a polished watercolor technique which were popular in France in the 1870s and 1880s. Often eighteenth century in subject, they satisfied in a nostalgic vein the taste for the art of the *dix-huitième* as it spread beyond the circle of connoisseurs and critics to the middle class. Larsson used his fluent watercolor technique not only as a *plein-air* device but also as a means of describing costume in an eighteenth-century style, and the taste for the decorative atmosphere of the Rococo acquired in Grèz would remain a constant element in his work.

Plein-air painting for Larsson was as much an attribute of French country life as it was a pictorial style. Although his first successful watercolors depicted local farm people, country life for him was not the hard rural existence of the working peasant but rather the sunlit or autumnally silver kitchen gardens and vine-covered walls of a picturesque village where his new found familial life could be lived in the ease and outdoor freedom of a community of kindred spirits. This French sense of domestic *douceur de vivre,* so different from his own harsh and impoverished childhood, made a deep impression and was to be an important motivating force in the creation of the idyll in Sundborn.

The house at Sundborn was the gift of fate, through the medium of the woman Larsson had married, Karin Bergöö. It was given to the couple as a summer house in 1889, on the death of an aunt who had lived in it, by Karin's father. Thus Karin, in addition to her actual role as mother of the family and co-designer of the domestic environment, and her eventual pictorial role as chief character in the Sundborn paintings, was also the immediate cause of their possession of the place which would enable Larsson to fulfill his particular decorative and pictorial gifts. They began to work on it right away, starting an English cottage garden in 1889, adding a studio in 1890, widening windows, constructing shelves and moldings which acted as framing devices to each wall, designing simple furniture for the local carpenters to build, painting friezes, door panels, and overdoor designs, tiling the roof, and facing the exterior in board-and-batten style painted dark red with white ornamental trim. By 1894 the little log cabin farmhouse was a full-fledged "artist's house." Although there would be further additions, the essential aesthetic character of it was established.

The decorative aesthetic of Sundborn combined a Continental sophistication with a National Romantic feeling for the Swedish countryside and its traditions. If Larsson had gone looking for a country cottage in which to realize his social and decorative ideals, he probably would have looked in Dalarna, where Sundborn is, because it is the Swedish province richest in folk history and decorative traditions. Of particular interest to him were the local peasant wall paintings in farmhouse interiors, which combined biblical narrative in local costume, vigorous floral patterns, and extensive decorative use of lettering in words and phrases (see illustration on p. 15). These wall paintings, still being made up until the early years of the nineteenth century, had fallen victim to the rural dislocations of mid-century and were in danger of being permanently lost. Larsson was one of those people like Artur Hazelius, the founder of Skansen, the outdoor architectural museum in Stockholm which opened in 1891, who saw the quality and vitality of these ensembles, and in 1912 he engaged in a rescue project of his own, acquiring a room with peasant paintings and adding it to the Sundborn house. Although he never tried in his

own wall paintings to emulate or recreate the peasant style, he took from it the sense of the cottage wall as a divided decorative field, and in particular the use of painted words and mottos as elements of design (see *Old Anna,* p. 14).

A second component of Larsson's style was also Swedish but had the French inflection that so strongly marked the art of court circles in the eighteenth century (see pp. 30 and 31). The Swedish royal palaces were decorated by French and French-trained artists, and their formal Louis XV and Louis XVI style was translated in aristocratic country houses into a fresh and charming provincial Rococo. The porcelain tile stoves—sometimes plain but often decorated, as in *Brita's Nap* (p. 16)—the painted furniture and simple printed fabrics, and the white walls with painted floral designs seen in the little bedroom at Gripsholm Castle (see illustration on p. 17) are all elements which are found in both the bedroom and the sitting room at Sundborn.

The third element of Larsson's style and taste was international and was composed of the many new ideas about decorative form then emergent in England and the Continent. Like others of his progressive generation Larsson was profoundly affected by the Japanese aesthetic, with its taste for light, airy rooms, strong linear emphasis, and flowing, assymetrical design (he wrote in *De mina* in 1895 that Japan was his "artistic fatherland"). Though settled in Sweden after 1885, he travelled regularly to Paris and elsewhere on the Continent and was aware not only of the Japanese art being exhibited during those years but also of European *Japonisme* and the early stages of Art Nouveau, especially in Brussels, where he was invited to show at *Les XX* in 1891, the year in which decorative arts were first prominently featured in the group's annual exhibition. Karin sometimes travelled with him and she went also to England, where her sister had married. Thus directly, as well as through Continental exhibitions and publications, the Larssons were aware of the ideas of the English Aesthetic Movement which challenged mid-Victorian ornate solidity with a new conception of lightness, simplicity, and the use of flat pattern rather than elaborate carving as a means of decorating surfaces. Charles Eastlake's praise (in *Hints on Household Taste,* which went into four editions after 1867) of "individually designed pieces specially made by rural craftsmen" is directly relevant to the Larssons' method, as is Charles Annesley Voysey's advice, published much later but coming out of the same aesthetic: "Be not afraid of bright color; it is a powerful aid to cheerfulness. Avoid crude mixtures of many colors, for cheerfulness and harmony can be secured with a few...Rejoice not only in the colors of living nature, but above all in the proportions of her color schemes" (*The Craftsman* 23, November 1912).

In thus setting out in the early 1890s to make an "artist's house" with consciously distinctive yet integrated aesthetic interiors marked by an original fusion of modern ideas with traditional idioms, the Larssons provide one of the early examples of the influence in Europe of the Arts and Crafts movement. The range of the Arts and Crafts philosophy also extended beyond the qualities of the individual house to include the social idea of a small but "artistic" house for everyone in which well designed objects of daily use would improve the quality of life for all. Moved by this dream, the Belgian artist Henri Van de Velde would in 1895 not only build his own house and design all its furniture but would also leave painting to become a designer of objects and ultimately an architect. English architects such as R. A. Briggs and C. H. Townsend not only built houses for a new clientele but published articles in *The Studio* with such titles as "Bungalows and Country Houses" (vol. 3, 1894) and "An Artistic Treatment of Cottages" (vol. 6, 1895) in which they gave helpful practical advice to present or prospective owners. Townsend's "An Artistic Treatment of Cottages" in particular must have interested the Larssons because it met the problem which they had just solved, that of "transformation of a farm laborer's two or three-roomed cottage into a home for gentlefolks." Although Larsson was

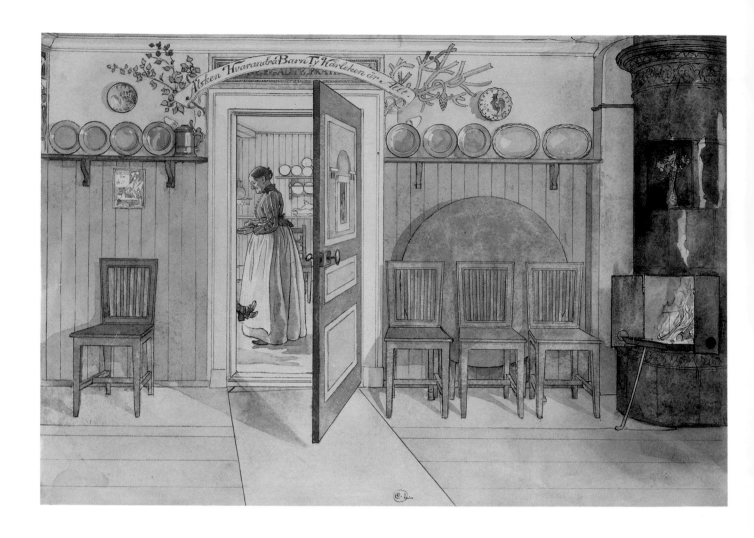

Carl Larsson
Old Anna *circa* 1895
Gamla Anna
Watercolor on paper
32.0 x 43.0 cm. (12⅝ x 17 in.)
Published in *Ett hem,* 1899
[Collection: Nationalmuseum, Stockholm, Sweden]
Cat. no. 15

In contrast to the delicate summer blue and white of the Sundborn sitting room, the dining room was decorated in a hearty winter red and green. In thus creating a different decorative ambience for separate rooms, the Larssons were adapting the freshest English style. The view here is from the dining room into the kitchen; the opposite wall of the dining room is seen in Before a Little Card Party *(cat. no. 30). Over the door is painted a curious double motto flanked by plant motifs. The illusion is created of a classical lintel engraved in Roman style with the French motto, "Liberté Egalité Fraternité." Floating in front of it is a narrow scroll inscribed in Dalarnan-style script with a phrase that translates as "Love one another, children, for love is all." One wonders whether this spiritual message was intended to complement or to contradict the more secular slogan beneath it. Through the door is seen the family servant Anna Danberg, who also occasionally served Larsson as a model (see* The Studio, *cat. 16). Evident in this painting is the pleasure the artist took in playing straight and rounded shapes against one another, and in composing with large simplified areas of local color.*

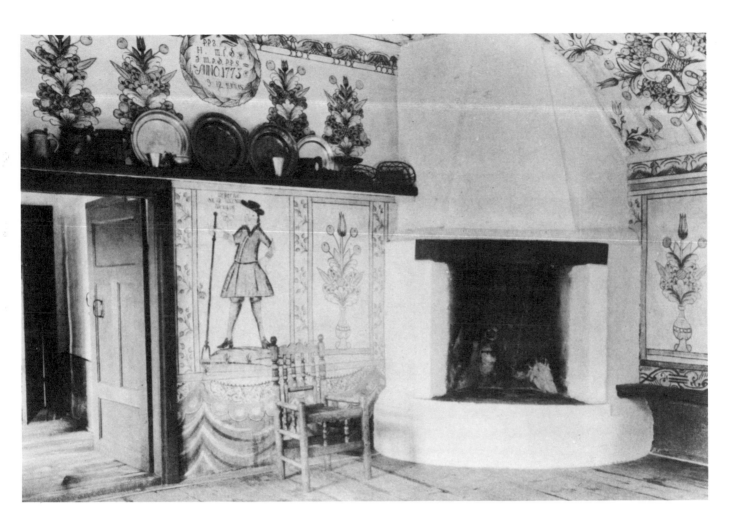

Painted interior from
a mid-eighteenth-century
Hälsingland farmhouse
now in the open-air
museum in Skansen,
Stockholm.

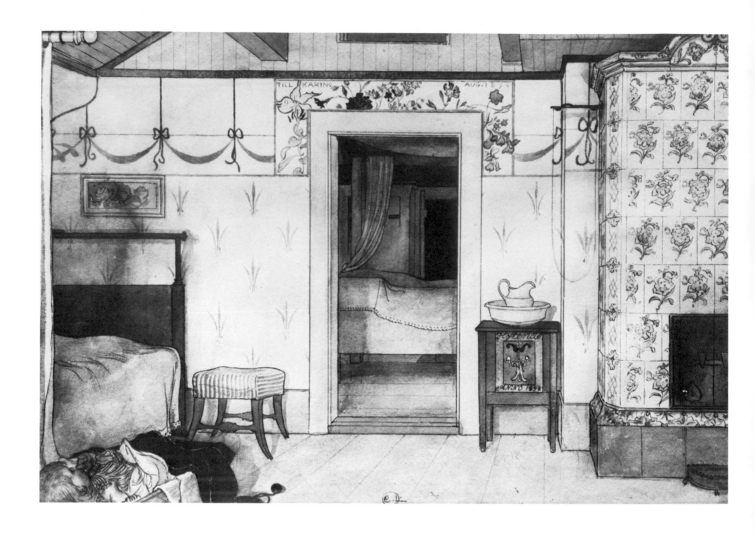

Carl Larsson
Brita's Nap *circa* 1895
Britas tupplur
Watercolor on paper
32.0 x 43.0 cm.
(12⅝ x 17 in.)
Published in *Ett hem,* 1899
[Collection: Nationalmuseum,
Stockholm, Sweden]
Cat. no. 18

The room glimpsed through the door in Papa's Room *(see p. 50) is this one, where Karin and the younger children slept (three girls—Lisbeth, Brita, and Kersti—were born between 1891 and 1896). Unlike the solid-color walls of the other rooms, the walls here are treated in the manner of the papered rooms of the Aesthetic Movement, with both wall and frieze decorated in different patterns. Here the pattern is painted directly on the walls, a simple stencil-like pale-green trefoil shape in the main field and a frieze of rose-colored ribbons and swags. The overdoor, inscribed "For Karin Aug. 1894," depicts wild flowers flowing across the decorative field and cut off by the lintel as though still growing outdoors. The randomness of the overdoor design plays against the regularity of the wall patterns and the repeat of the stove tiles, whose soft rose and green colors are echoed in the wall and frieze. The atmosphere of country Rococo which is evoked fuses in a remarkable way the charm of the boudoir with the innocence of the nursery.*

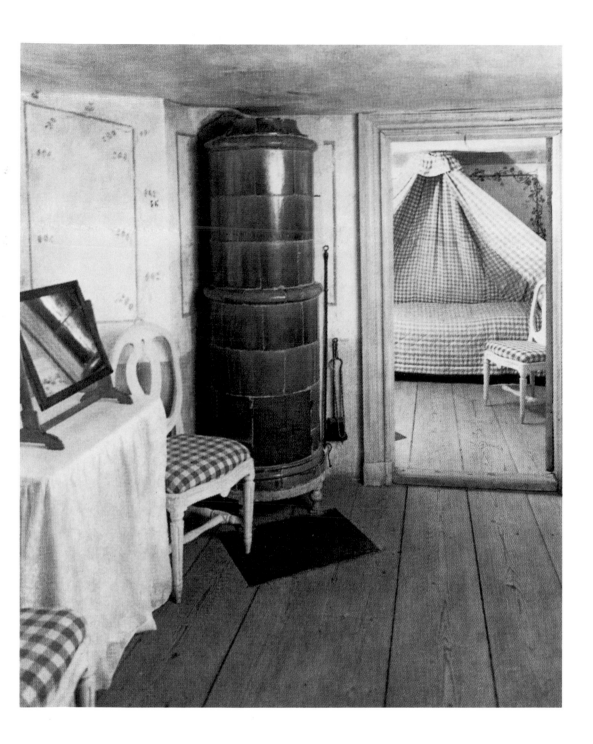

Gripsholm Castle, Sweden.
Mid-eighteenth-century
room of the princesses'
lady-in-waiting.

neither an architect nor a designer like his wife Karin (whose energies were completely taken up by producing useful things for the house and family), he clearly felt the need to celebrate and communicate to others what he had accomplished.

Larsson began in a form familiar to him as an illustrator: he wrote and published in 1895 a book illustrated with black and white drawings called *De mina*. The full title of the book, *De mina och annat gammalt krafs,* translates approximately as "My folks and other old scraps"—a curious blend of rough cameraderie and self-deprecation that unsuccessfully attempts to hide the pride he took not only in his house but also in his family, which by 1895 included five of a total of seven children. Yet he was essentially a visual artist and not a writer, and it was in the series of twenty-four watercolors probably begun that summer or the next and exhibited in 1898 that he truly achieved the goal of celebrating his life at Sundborn. In 1899 these images were printed as a book of color plates with a prefatory text written by Larsson and decorated by him with line vignettes. It was simply called *Ett hem (A Home),* and with its publication the successful reception of the exhibited watercolors was multiplied throughout a wide public. Between 1899 and 1913 Larrson would publish four more books in a similar format, of which *Larssons* (1902) and *Åt solsidan* (1910) continued the specific theme of the family interiors—some in Stockholm where they spent the winters before 1900; some in Falun, the town near Sundborn where the children stayed during the school week; but most at the house in Sundborn.

It is not clear whether Larsson had eventual publication in mind when be began the *Ett hem* watercolors: he himself seems to have liked people to think he began to make them by accident, as a result of glimpsing a child in a piquant pose, or because Karin needed to find something to occupy his time during a rainy summer. But examination of the pictures makes clear that they were neither accidental nor casual: despite the air of informality they were carefully composed images (see cat. no. 16) and assume a logical place in the artist's development. Although he had been occupied by several large mural projects as well as by teaching and illustration in the decade since leaving Grèz, he had also painted some domestic subjects in a Naturalist style (see cat. no. 5). By the early nineties, as the family grew, he turned more often to studies of Karin and the children, whether in watercolors or ink drawings. Their number increased in 1894, which was also the year in which he illustrated the folk tale *Singoalla* (see cat nos. 65 and 66). In the *Singoalla* drawings particularly, the evolution from a Naturalist to a linear, decorative style can be traced, and in the *Ett hem* watercolors this mature, confident style finds complete expression. Thus his watercolor style—and it is in watercolor that he works best—matured during the same years in which he was painting the wall decorations in the interiors at Sundborn. The feeling for linear clarity, for the placement of shapes on a flat surface, and for the relationships of a few carefully chosen local colors that one sees in the house interiors of 1892-94 are also present in the paintings of 1895-96. It comes as no surprise that when Larsson travelled to Italy in the spring of 1894 to study fresco painting for a mural project in the Swedish Nationalmuseum, he wrote with great enthusiasm about the artists of the late Quattrocento, particularly Botticelli and Verrocchio, with their clearly defined colors, sinuous line, and precise graphic detail.

For Larsson, as for many other Europeans in the early 1890s, the work of the English illustrator and decorative artist Walter Crane was an important medium for the transmission of the new decorative aesthetic. He would have seen Crane's Peacock Frieze at the Paris World Exposition of 1899, where one of his own triptychs—a work that he had done for his Swedish patron Pontus Fürstenberg—was exhibited. He may also have known Crane's illustrated books for children even before 1891, when sixteen of them were exhibited to great acclaim at the same *Les XX* exhibition at which he showed three paintings. (The motto adapted from a Kate Greenaway verse on the door in *In the Corner,*

p. 20, tells us that children's books in the new English style were certainly part of the Larsson family by the early 1890s.) The relationship with Crane's work goes beyond the new qualities of design which the English master brought to the art of illustration. Crane's characteristic female figures, graphic versions of the medievalist *belles dames* of Sir Edward Burne-Jones and other late Pre-Raphaelites, have a clear affinity with Larsson's willowy, sometimes remote figure of Karin, whose pensive inward mood often seems at odds with the sunny good cheer around her. Furthermore, Larsson's Sundborn watercolors are doing very much what Crane's imagery in his Sixpenny Toy Books and such childrens' classics as *Cinderella* and *The Three Bears* did in the 1870s: they are communicating a style of interior design and decorative furnishing. Mark Girouard in his book *Sweetness and Light: The 'Queen Anne' Movement 1860-1900* (Oxford, 1977) emphasizes the importance of the picture books of Crane and his followers in transmitting the details of the new "Aesthetic" style: "…the best advocates for 'Queen Anne' were to be found in the nursery… Like little aesthetic time bombs they scattered sweetness and light beyond the nursery into every corner of the house." In Crane's pages the figures are composed in a single decorative unity with the patterns of tiles, carpets, draperies, and costume. Although the pictures of such followers of Crane as J. G. Sowerby and his brother Thomas Crane (see p. 21) lack his genius, their settings are full

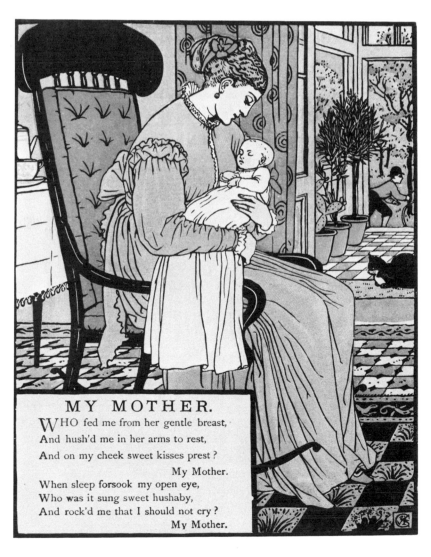

Walter Crane
Page one of "My Mother"
(London: George Routledge and Sons, 1873)
[Collection: The Metropolitan Museum of Art, New York, Rogers Fund, 1921. 21.36.159]

My Mother *was one of a series of "Sixpenny Toy Books" illustrated by Crane in the 1870s.*

MY MOTHER.

WHO fed me from her gentle breast,
And hush'd me in her arms to rest,
And on my cheek sweet kisses prest?
　　　　　My Mother.
When sleep forsook my open eye,
Who was it sung sweet hushaby,
And rock'd me that I should not cry?
　　　　　My Mother.

Carl Larsson
In the Corner *circa* 1895
Skamvrån
Watercolor on paper
32.0 x 43.0 cm. (12⅝ x 17 in.)
Published in *Ett hem,* 1899
[Collection: Nationalmuseum, Stockholm, Sweden]
Cat. no. 12

The twenty watercolors that make up Larsson's classic book Ett
hem *were exhibited in Stockholm in 1897 with great success.
Though the series is traditionally assumed to have been started
in the summer of 1894, it seems more reasonable to date them a
year or two later. They show a remarkable consistency of style,
and several of them have to have been done in 1896 or possibly
1897, owing to the presence in them of the child Kersti, born
in 1896.*

*Larsson referred to this picture of Pontus in the sitting room
as the "urbladet" or original sheet, and said it was prompted by
the sight of the sad little boy, dismissed from the supper table
for misbehavior, slumped on a chair in the pretty room. Yet
many of Larsson's "stories" about his subjects were probably
dramatizations after the fact: he had been looking to his
domestic surroundings for subjects for some time, and it is
unlikely that he waited either for accidental situations or for*

*the rainy weather that legend has it was the immediate cause of
Karin's suggestion that he begin these pictures. More likely,
Pontus's true "punishment" was to sit inactive in a chair long
enough for his father to draw him.*

*At any rate, the real subject of the picture is the room itself:
the fresh combination of striped cloths and figured tiles, the
pictures and sconces on the wall, and the central doorway
painted in Larsson's characteristic fusion of wavy assymmetrical
Art Nouveau forms and private iconography. Karin's profile
appears on the bottom panel of the door, and the top panel is
inscribed with Larsson's own variation of a verse by Kate
Greenaway in which he changes "there was an old woman/lived
in a hill" to "there was a little woman/lived with CL." Over the
door, as though glimpsed through a high window, is the top of a
classical temple surrounded by blowing leaves that echo the
forms of the panel beneath. Next to the splendid eighteenth-
century tile stove decorated with folk motifs the artist has
painted an illusionistic pole strung with garlands. On the wall
at the left hangs an 1886 Larsson etching entitled* Den glada
festen *(The Happy Celebration). Its eighteenth-century setting
is quite appropriate to this room in which the pale colors, the
floral motifs, and the white chairs with their blue-striped
seatcovers all possess the distinctively French character of
Swedish Rococo.*

of such elements of the progressive new style as blue-and-white porcelain, floral dado, and Japanese screens. While Sundborn was not fashionable London, and Larsson's interiors, though shaped by the Aesthetic Movement, were not composed of the same specific elements, when published his images functioned in a related way.

Although Larsson's pictures were not made especially for children, they are very much about the seven children who formed with their mother the figures in his domestic imagery. At their best these images radiate the artist's affection for these young persons and the seriousness with which he took them: though he falls from time to time into the "cuteness" and triviality of sentimental Victorian genre, for the most part he avoids these pitfalls and grants the children the right of aesthetic distance, making action subordinate to style. Since the life of children within and without the house became the theme of his pictures, it is not surprising that he responded so thoroughly to the style of Walter Crane, Kate Greenaway, and the many other illustrators of the English school whose linecuts figure so largely in the volumes of *The Studio* in the 1890s. Another contemporary illustrator for children who may have provided a model for Larsson is Maurice Boutet de Monvel, whose books were published in Paris in the 1880s and 90s and to whom an article was devoted in *The Studio* in 1895. While Boutet's best known work is his series of illustrations of the life of Joan of Arc, he also illustrated such contemporary morality tales for children as *Nos Enfants* and *Filles et Garçons* by the novelist Anatole France. These watercolor drawings are made with clear simple outlines and areas of delicately pale local color. In *Filles et Garçons* the settings are mostly domestic interiors with charming details of French wallpapers and drapery patterns. The children,

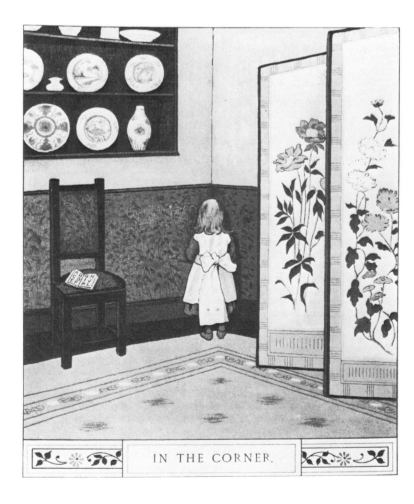

IN THE CORNER.

J.C. Sowerby and
Thomas Crane
"In the Corner"
from *At Home,*
(London, 1881)

Carl Larsson
Required Reading
circa 1898
Ferieläsning
Watercolor on paper
46.0 x 64.0 cm.
(18⅛ x 25¼ in.)
Published in *Larssons,* 1902
[Collection: The Art Museum
of the Ateneum, Helsinki,
Finland]
Cat. no. 22

The Larssons' son Pontus, here about ten years old, is seated at a table doing the reading required during his spring vacation (the literal translation of the painting's Swedish title is "Holiday Reading"). Outside the window the sunny day and the blossoming lilacs beckon the child away from his work. The brick-red walls and ivy-green furniture of the Larssons' Stockholm home recall the colors of the dining room at Sundborn. To keep the palette restricted, Larsson has even made the picture within the frame a block of green.

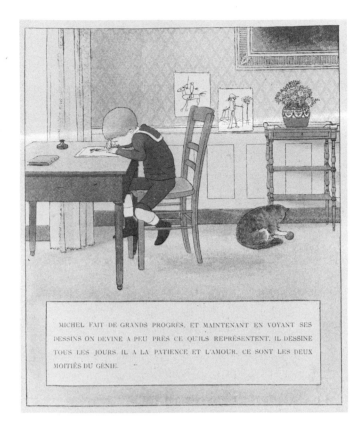

MICHEL FAIT DE GRANDS PROGRÈS. ET MAINTENANT EN VOYANT SES DESSINS ON DEVINE A PEU PRÈS CE QU'ILS REPRÉSENTENT. IL DESSINE TOUS LES JOURS. IL A LA PATIENCE ET L'AMOUR. CE SONT LES DEUX MOITIÉS DU GÉNIE.

Maurice Boutet de Monvel
"Michel fait des grands progrès"
from *Filles et Garçons*
by Anatole France
(Paris, *circa* 1887)
[Collection: The Metropolitan Museum of Art, New York, Harris Brisbane Dick Fund, 1924. 24.46.20]

whose daily activities illustrate the unsentimental wisdom of the text, are observed with clarity and possess a grave dignity which comes from their complete translation into pictorial style. The quality of Boutet de Monvel's illustrations was rare, and to a lover of French life like Larsson for whom children were also becoming a pictorial theme, they would have had an immense appeal.

The watercolors in *Ett hem* are almost miniature, not very much larger than the pages of the wide book in which they were published. Although a few of them are without figures, or nearly so, in their color and graphic animation they are worlds apart from the inwardness and solitude of the empty rooms of his Symbolist contemporaries. The scale of figures is small in relation to the decorative settings which claim so large a part of Larsson's pleasure and energy. As he contined to make domestic paintings in the later 1890s and through the following decade, he began to enlarge the scale both of the sheet itself and of the figure within the field. *Suzanne and Another* (see cover) is an early example of this development. In the pictures he made in 1908-09, many of which appear in *At solsidan,* the figures acquire a new physical and psychological weight. While these pictures have the same grid structure, supple outline, and sense of color relationships as the earlier ones, the figures in them command a place equal to the setting. There is also a new observation of light as it enters windows and creates shadow patterns on walls and highlights on rounded or polished surfaces. Taken together, these developments reveal an affinity with the pictorial photography which had been exhibited and published in London, Paris, Munich, and other European centers since the late 1890s. Indeed, there were several artists in the new movement—for example Clarence White and Gertrude Käsebier—with whom Larsson shared a feeling for carefully composed images of children and of women in flowing draperies. If we compare a photograph like Käsebier's *The Sketch* (see p. 25) with Larsson's *Karin by the Shore* (reproduced on p. 6) we are struck by the likeness of structure and mood. In both, the profile figure is a curved

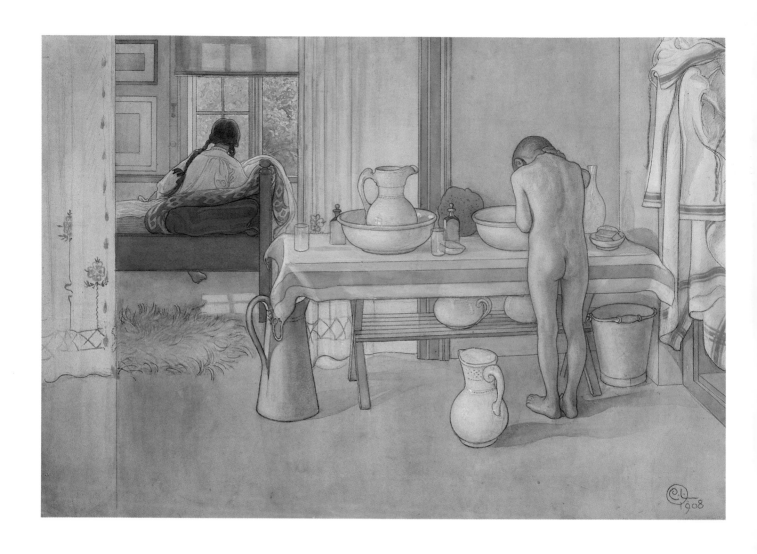

Carl Larsson
Summer Morning 1908
Sommarmorgon
Watercolor on paper
50.2 x 71.0 cm. (19¾ x 28 in.)
Published in *Åt solsidan,* 1910
[Collection: Mr. and Mrs. Arthur G. Altschul, New York]
Cat. no. 39

*The two youngest Larsson children—Kersti and Esbjörn—are
getting up in a room filled with the early sunlight of a warm
summer day. This is one of the finest of the paintings in* Åt
solsidan *in that the charm of the figures is completely
integrated into a construction of wonderfully delicate color
geometries. Vertical bands of white, gold, green, pale pink,
sage, and lemon move across the upper two-thirds of the field,
and are intersected by the horizontals of the bed, table, and
striped tablecloth. Framed pictures, windowpanes, and patches
of sun make rectangles within a larger rectangle. Within this
grid are set the simple, satisfying curves of the bowls and
pitchers that surround the sturdy yet vulnerable boy like forms
of maternal protectiveness.*

silhouette defining the front plane of the picture from top to bottom in a strong vertical band crossed by the horizontal bands of the landscape ground. The mood of gentle dreaminess, frequent in Käsebier, is uncommon for Larsson except in his pictures of Karin. One need not assume that this particular photograph was known to Larsson, though it could have been, since Käsebier's work was known and exhibited in London and a number of European cities in the early years of the century. Both images have their roots in the aesthetic of the nineties, in particular that aspect of the Symbolist and late Pre-Raphaelite mood which is concerned with the ideas of innocence and purity and finds a visual equivalent of these spiritual attributes in the figures of pensive women or angelic children clearly silhouetted on a flat surface: pure line on inviolate plane. Much of the appeal of Larsson's domestic pictures lies in this kind of innocence—the innocence associated with a certain conception of childhood, with gardens, and with the maternal hearth. While it was important for Larsson to insist upon the literalness of this dream, at nearly a century's distance we may perhaps forgive him this need and enjoy without prejudice the simple pleasures of his domestic, pastoral vision.

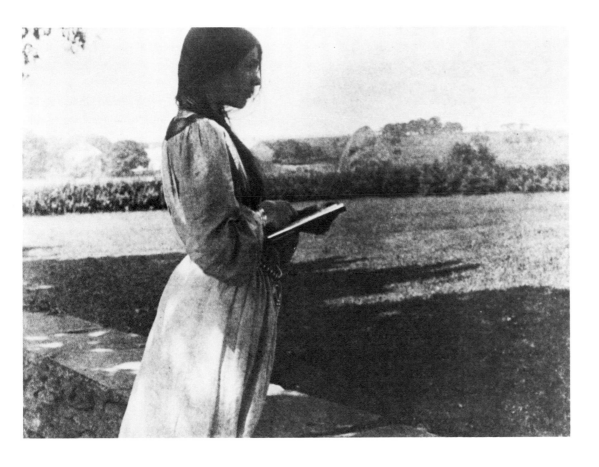

Gertrude Käsebier
The Sketch *circa* 1899
Platinum print
15.0 x 21.0 cm. (6 x 8¼ in.)
From William Innes Homer, *A Pictorial Heritage:*
The Photographs of Gertrude Käsebier
(Wilmington, Del: Delaware Art Museum, 1979), pl. 21.

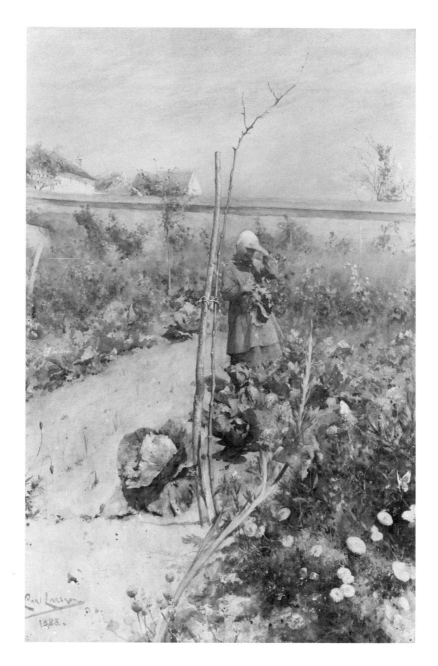

Carl Larsson
In the Kitchen Garden 1883
I köksträdgärden
Watercolor on paper
93.0 x 61.0 cm. (36⅝ x 24 in.)
[Collection: Nationalmuseum,
Stockholm, Sweden]
Cat. no. 2

*The year 1882 was an important turning point for Larsson.
That summer he went with the Swedish artist Karl Nordström
to Grèz-sur-Loing, the village southwest of Paris which had
become a center for the Scandinavian artists who were
absorbing the lessons of French Naturalism. Recovering from
the illness and depression brought on in part by his failures at
the Salon, he became a lively member of the artists' group
there and began in their company to fully open himself to the
the* plein-air *painting that stimulated his colleagues. He was
rewarded at the Salon of 1883 with a gold medal for his
submission of watercolors of Grèz motifs.* In the Kitchen
Garden *was one of two paintings bought from the Salon by the
Nationalmuseum in Stockholm. Two other watercolors, also
single figures of peasants in a vegetable garden, were bought
by the Gothenburg merchant-patron Pontus Fürstenberg,
whose patronage was to be of great importance to Larsson after
his return to Sweden in the later 1880s.*

The son of a coachman and a maidservant, Carl Larsson was born in Stockholm in 1853 and grew up in the city's slum. His childhood was gloomy and unhappy, and he later said of himself that he was "a poor little neglected wretch, ugly and regarded as stupid, always in the way at home and never welcomed abroad, in fact quite browbeaten."

Larsson entered Stockholm's Royal Academy of Fine Arts in 1866, when he was only thirteen. There he fell in love with a fellow student, who died in 1876 while giving birth to their child. To help support his family, he worked first as a retoucher of photographs and then as an illustrator for a comic magazine. He extended his repertoire by doing reportage for weekly newspapers and at twenty-two was already receiving important commissions.

In 1877 Larsson received a five-year travel grant from the academy and went to Paris, where a new generation of Scandinavian artists was active in the 1870s and '80s. Aiming at grand art and attempting bizarre, extravagant subjects, he had a difficult time and met with little success at first. Intended for the Salon, his works of the late 1870s were either never completed or were refused. Displaying the same fantastic quality found much later in his vast *Midwinter Sacrifice*, these paintings are indicative of the melancholy and despair that he hid so well from his friends but which drove him to the verge of suicide. Their Romantic imagery was at odds with the Naturalism then in force, and it took him some time to respond to and absorb the light palette, Realist technique, and everyday subject matter that would ultimately be of such importance to him. Although he painted a few landscape studies in oil at Barbizon in 1877, it wasn't until 1882, when he settled in Grēz-sur-Loing, that he began a serious study of *plein-air* painting.

Grēz, a small village south of the Fontainebleau Forest not far from Barbizon, was a picturesque hamlet with an old vaulted stone bridge, a moss-clad medieval church, and gray stone houses with gardens extending in terraces down to the River Loing. British, American, and Scandinavian *plein-air* painters flocked to the village's two pensions, Mme. Chevillon's Hotel Seine et Marne and Mme. Laurent's Hotel Beausējour, a former monastery. During his first two years in Grēz, Larsson lived at Mme. Laurent's, but after his marriage to his fellow Swedish artist Karin Bergöö in 1883 he and his wife rented the summer pavilion in Mme. Chevillon's garden. According to the Swedish writer August Strindberg, life at these pensions was simple and unconventional, with everyone dressing to their own taste and people entertaining themselves in the evenings with singing and dancing. In this easy-going environment, Larsson became the acknowledged leader of a circle of friends that included the Swedish artists Karl Nordström, Richard Bergh, and Nils Kreuger, the Finnish sculptor Ville Vallgren, and the Norwegian painters Christian Krohg and Christian Skredsvig.

The Grēz school of painting was intimate and realistic, and like a number of Grēz artists Larsson tended to work in watercolor. Reproducing details from his immediate surroundings, he painted patches of garden and peasant men and women in their work clothes. These motifs sold well, earned him a medal at the Salon of 1883, and attracted the attention of such discerning Swedish collectors as Pontus Fürstenberg, the wealthy Gothenburg financier who was to become his major patron. Convinced that he was on the right track, he wrote home, "I've now opened my arms to Nature, no matter how simple it may be. The rutting, spawning earth is henceforth to be the subject of my painting."

One of the first Paris-trained Swedes to give in to the spirit of National Romanticism that swept Scandinavia in the 1880s, Larsson returned to Sweden in 1885, settling in

Carl Larsson: A Brief Biography

Görel Cavalli-Björkman

*Curator,
Nationalmuseum,
Stockholm*

Carl Larsson
Interior of the Fürstenberg Gallery 1885
Interior fran Fürstenbergska galleriet
watercolor on paper
78.0 x 56.5 cm. (30¾ x 22¼ in.)
[Collection: Göteborgs Konstmuseum, Sweden]

Pontus Fürstenberg, seated in the foreground, was Larsson's earliest patron and enabled him to establish his career when he returned from France to Sweden in 1885.

Stockholm, where he rented an old house with a large garden and a view over the water. A leader of the young artists who opposed the conservative Royal Academy, he helped organize the opponents' pioneering exhibition *From the Banks of the Seine* that April and their second exhibition that September. The following year he moved to Gothenburg, where he helped found the Swedish Artists' Union and with the help of Fürstenberg became a teacher at the Gothenburg Museum's Painting and Drawing School, a laboratory for testing such radical union ideas as the mixing of male and female students.

Despite his success with watercolor, Larsson was unwilling to restrict himself to that medium. Looking for bigger tasks, he produced for Fürstenberg's gallery three large decorative-symbolic canvases entitled *Renaissance, Rococo,* and *Modern Art.* Mounted in a frame of figures modelled and cut in wood by his own hand, they were displayed at the Paris World Exposition of 1889. Fürstenberg also commissioned him to paint a mural for the large open staircase of the local girls' school; in it he portrayed Swedish women from different periods of history.

An even more ambitious effort in the field of monumental art awaited Larsson in Stockholm, where, more than twenty years after the opening of the Nationalmuseum, he was to paint on the ample walls of its lower staircase the frescoes that the German architect F.A. Staler had recommended when the museum was first planned. Having won a design competition for the project by submitting a number of studies between 1888 and 1890, he returned to the capital in 1891 to begin work on a mural that would depict six subjects from the history of Swedish art. After travelling to the Continent in

Carl Larsson
The Library at Drottningholm Castle *circa* 1895
Pencil and watercolor on paper
50.6 x 33.4 cm. (20 x 13⅛ in.)
[Collection: Nationalmuseum, Stockholm, Sweden]
Cat. no. 70

The scene in the Nationalmuseum fresco in which Tessin shows drawings to Lovisa Ulrika (see illustration on p. 31) is set in the library at Drottningholm, a royal residence outside of Stockholm. The castle was rebuilt and decorated throughout the course of the eighteenth-century by French and French-trained artists, and Larsson's study quite meticulously records the details of the Louis seize *décor, the style called Gustavan in Sweden for the patron-king Gustavus III, Lovisa Ulrika's son. In the finished work we can see the same architectural details as in this study, except that for compositional purposes Larsson has reversed the position of the two panels of the rear wall.*

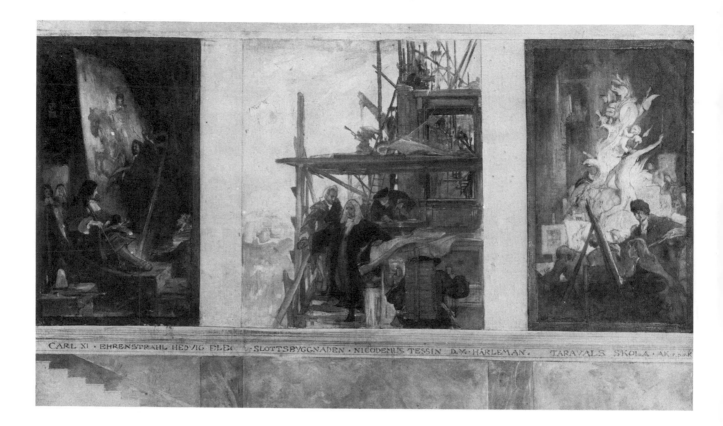

CARL XI · EHRENSTRAHL HEDVIG ELEO v · SLOTTSBYGGNADEN · NICODEMUS TESSIN D.Y. HÅRLEMAN. TARAVALS SKOLA · AKADEMIK

Carl Larsson
**Scenes from Swedish Art History:
Ehrenstrahl and Carl XI;
Nicolas Tessin the Younger with Hårleman;
Taraval's Academy. Studies for the Frescos
in the Nationalmuseum, Stockholm** 1890-91
Oil on canvas
110.5 x 134.0 cm. (43½ x 52¾ in.)
[Collection: Nationalmuseum, Stockholm, Sweden]
Cat. no. 63

*This and cat. no. 64 are the proposals that won for Larsson
the commission to make the frescoes for the stairway hall of the
Nationalmuseum (see cat. no. 9). The theme of scenes from
Swedish art history was not set by the jury but was proposed by
Larsson and prevailed over his chief competitor's religious
subject. At the left, David Klöcher von Ehrenstrahl (1629-98),
court portraitist of the later seventeenth-century, works on a
large equestrian portrait of King Carl XI while the king poses.
The center panel shows the architect Nikodemus Tessin the
Younger (1654-1728), who as Superintendant of Royal
Buildings devoted his life to the rebuilding and decoration of
the Royal Palaces at Stockholm and Drottningholm. Behind
him on the stairs is his aide Karl Hårleman (1700-53), who,
with Tessin's son Carl Gustaf, took over Tessin's projects at
his death. In 1728 Hårleman and Carl-Gustav Tessin invited
a number of French artists to come and work on the interiors
of the royal buildings, thus firmly establishing a French style
that would continue to the end of the century. Among these
artists was a student of François Boucher named Thomas
Taraval (1702-50), who is shown in the right-hand panel in
his own school of painting. Taraval's school was a place where
Swedish artists could receive French training before going on
to Paris, and it became the basis for the Swedish Royal*

*Academy of Fine Arts. Less clear in the sketch than in the
finished work is the fact that the students are painting from a
live nude model. There were a number of changes made in all
three scenes of the final fresco, largely in the direction of
greater clarity and a firmer structure.*

Facing page, top:
Carl Larsson
**Scenes from Swedish Art History:
Lovisa Ulrika and Tessin;
Gustavus III; Sergel in his Studio.
Studies for the Frescoes in the
Nationalmuseum, Stockholm** 1890-91
Oil on canvas
110.5 x 134.0 cm. (43½ x 52¾ in.)
[Collection: Nationalmuseum, Stockholm, Sweden]
Cat. no. 64

*During the second half of the eighteenth century, royal
patronage and a new generation of French-trained Swedish
artists and craftsmen enabled Sweden to develop an
independent classicizing style of great charm and interest. At
the same time many French paintings were added to the
royal—later national—collections. Here, Carl Gustaf Tessin,
the great diplomat and collector, is depicted in the left-hand
panel showing drawings and paintings that he brought from
Paris to Lovisa Ulrika, sister of Frederick the Great of Prussia
and Queen of Sweden from 1751 to 1771. It was due to
Tessin's wide acquaintance and cultivated taste that fine works
by Jean Baptiste Chardin, François Boucher, Nicolas Lancret,
and others entered the royal collections. (For his own collection,*

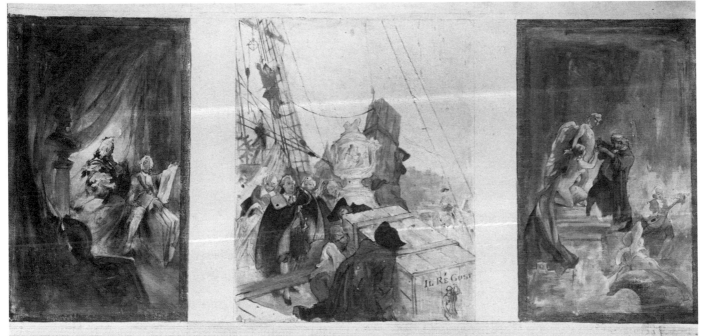

OVISA·ULRIKA· C·G·TESSIN·HANDT·TAF·GRAV·SAML· GUSTAF III · ANTIK SKULPTUR· SERGELS ATELIER·BELLMAN

Tessin bought at the great Crozat sale of 1741 no fewer than 2,057 drawings: see Dessins du Nationalmuseum de Stockholm, collection du Comte Tessin, *Paris, Louvre, 1970, introduction by Per Bjurström.) The panel depicting Tessin was much changed in the final version, both in composition and in setting (see above and right). The same is true of the center panel, which shows Lovisa Ulrika's son Gustavus III, who reigned from 1771 to 1792 and was noted for his extensive patronage of art, music, and drama. In 1783-84 Gustavus III travelled to Italy with the court sculptor Johan Tobias Sergel (1740-1814) to acquire classical sculptures. In the sketch he is shown on board a ship laden with crates, while in the more strictly composed final work he is seen admiring one of the newly arrived statues. The right-hand panel is devoted to Sergel himself, a Neoclassical sculptor of international reputation. He is depicted carving the marble group* Cupid and Psyche, *which was originally commissioned from Louis XV's mistress Mme. du Barry but subsequently acquired by Gustavus III when the death of the French king prevented its purchase (see C. Laurin, E. Hannover, J. Thiis,* Scandinavian Art, *New York, 1922, p. 108). While Sergel works he is entertained by the singing of Carl Michael Bellman (1740-95), a noted contemporary poet.*

Right: Lovisa Ulrika and Carl Gustaf Tessin, finished fresco, from the *Scenes from Swedish Art History* in the stairway hall of the Nationalmuseum, Stockholm. Completed 1896. *Photograph courtesy the Nationalmuseum, Stockholm, Sweden.*

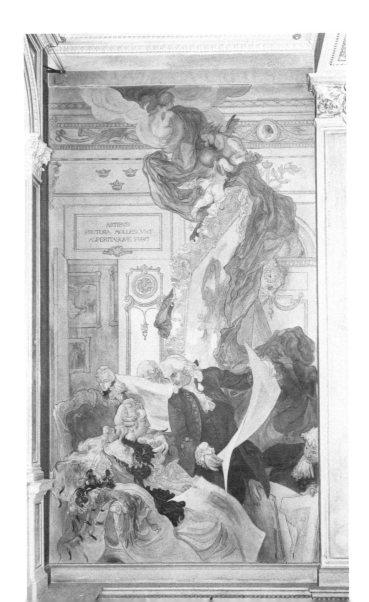

Carl Larsson
Girl with a Flower Garland
circa 1904
Charcoal and watercolor on paper
61.5 x 45.0 cm. (24¼ x 17¾ in.)
[Collection: Nationalmuseum,
Stockholm, Sweden]
Cat. no. 77

In 1907 a large frieze-like canvas was installed on the wall of the upper hall of the Nationalmuseum. It depicted the triumphal entry into Stockholm on Midsummer's Eve, 1523, of Gustav Vasa, the hero-king who had led the men of Dalarna in a successful victory over invading Danes. Larsson had worked on several studies for his composition before its final acceptance in 1906. A study of 1904, close to the final version, shows at the left a young girl in peasant costume seen from the back holding a decorative garland as she waits with the city fathers to welcome the equestrian king entering the city gate.

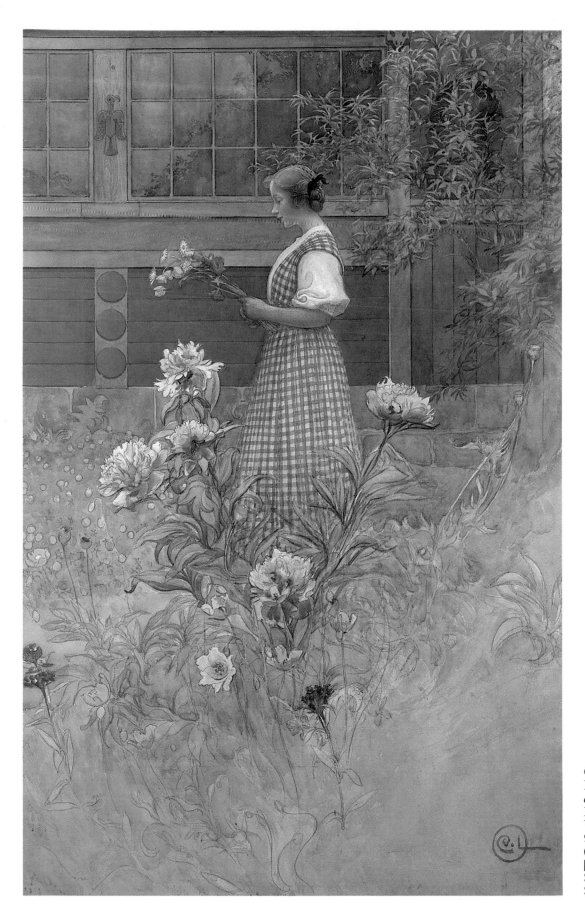

Carl Larsson
Lisbeth with Peonies
circa 1909
Lisbeth med pioner
Watercolor on paper
96.0 x 63.0 cm.
(37⅞ x 20¾ in.)
[Private collection,
Sweden]
See cat. no. 45 for commentary

Carl Larsson
Suzanne, Ulf, Pontus, Lisbeth June 1891
Ink on paper
46.5 x 29.0 cm. (18⅛ x 11⅜ in.)
[Collection: Albert Bonniers Förlag AB,
Stockholm, Sweden]
Cat. no. 81

*This drawing records one of the first
wall decorations that Larsson made
in the house at Sundborn.*

1894 to study fresco technique, he transferred his designs to the walls in 1896. Eleven years later, on the upper wall opposite the museum's entrance, he painted the hero-king Gustav Vasa entering Stockholm on Midsummer's Eve, 1523. In between time, he decorated a wall in Stockholm's Dramatic Theater and produced a large painting of the history of Swedish music for the foyer of the Stockholm Opera.

Although most of Larsson's murals dealt with Swedish art or history since the Renaissance, in the last years of his life he was haunted by a more ancient theme that he wanted to compose on the Nationalmuseum's entrance wall opposite the Gustav Vasa painting. To contrast with that midsummer scene he envisioned a midwinter picture showing the tragedy of one of Scandinavia's heathen kings sacrificing himself for his people. He made several sketches and finally a large oil painting entitled *Midwinter Sacrifice* (see illustration on p. 64). The work was provisionally hung in the museum in the summer of 1915, but the press was highly critical and the museum finally declined the painting, judging it brutal and melodramatic. The two-year debate that resulted was one of the most heated in the history of Swedish art.

By that time Larsson had already become famous for his watercolors of the little cottage at Sundborn that he and his wife had inherited from her two aunts in 1889. Used first as a summer house and then as a permanent residence after 1901, the cottage was extended as the family grew. In it the Larssons created a new idea for a home: a house marked by simplicity, airiness, and clear colors—quite the opposite of the dark, heavy, pompous style that then prevailed in bourgeois dwellings throughout Europe. In order to promote the home as a model, Larsson began painting watercolors of it in the mid-1890s and published his first set of them in *Ett hem (A Home)* in 1899. As he explained in the book's preface, he had produced the watercolors "not with the vain intention of simply showing how *I* live but rather because I imagine myself to have proceeded so sensibly that I believe it can serve as—dare I stand up and say it—as an example—there now, I've said it—for many persons who feel a need to arrange their home in a pleasant manner."

Happiness for Larsson was not just a beautiful home and a flourishing family of seven children (Suzanne, Ulf, Pontus, Lisbet, Brita, Kersti, and Esbjörn). National Romanticism and the dissolution of the old peasant society had led Swedish artists and writers to idealize life and work in the country, and he had a long-standing dream of a rural life close to the soil. Accordingly he added to his property at Sundborn and started to run a small farm that included seven cows and two horses and provided the family with milk, eggs, meat, and timber. Again figuring that his efforts could be instructive to others, he published in 1906 a book of watercolors of this family plot entitled *Spadarvet (My Little Farm)*.

The watercolors depicting Larsson's house and farm have little in common with the soft, subtle paintings of his French period, for he had changed from Naturalism to a decorative style. While working on frescoes he had learned to rely more on ornamental line and local color as a means of expression, and this style was perfectly suited to the technique of reproduction in a printed book. In all of his books, including the lesser known *De mina (My Family)*, published in 1895, and *Larssons*, published in 1902, he managed a highly personal combination of light-hearted pictures and colloquial text that was entirely new and had a huge public appeal. People found in his watercolors what everybody longs for: the happy aspect of life. Yet while documenting the charm of domestic life in a country cottage, he was able to avoid most of the sentimentality that characterizes anecdotal genre scenes of family life.

Despite Larsson's immense popularity with the public, there was a mutual lack of understanding between him and the rising generation of Swedish artists. His final

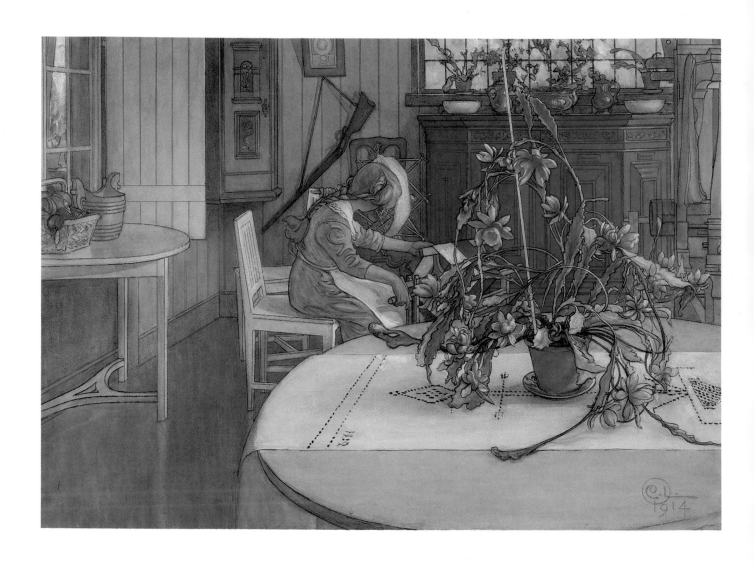

Carl Larsson
Interior with Cactus 1914
Interior med kaktus
Watercolor on paper
70.0 x 92.0 cm. (27½ x 36¼ in.)
[Collection: The Helsingborg Museum, Sweden]
Cat. no. 51

One of the latest of Larsson's Sundborn watercolors, this is set in the former studio, which after 1901 served as a workshop for Karin and the elder children. We are shown the end of the room opposite that seen in The Studio *(back cover). The window at the left, though it appears to open to the outside, is in fact looking into the bright sitting room (the window of the original cabin was not walled over but left in place when the studio was added in 1890). At the right is the loom on which Karin wove textiles for bedcovers and upholstery material, many of them in radical geometric designs akin to those of Navajo blankets (see illustration on p. 49). On the table is one of her simpler, more locally inspired embroidered cloths. The figure at work on the knitting wool could be Kersti, who was eighteen at the time and the only girl still at home. As in* Karin and Brita with Cactus *(p. 52), the almost predatory desert plant with its profusion of blossoms dominates the composition, providing a kind of rotary movement akin to that implied by the girl's turning of the wool winder. The gun hanging on the wall reminds us that since 1897, when Larsson bought the small nearby farm he called Spadarvet, he had had the farmer's need to protect the place from rabbits and foxes. Nonetheless, it seems arbitrarily crowded into the space and strikes an ambiguous note in this peaceful and productive room.*

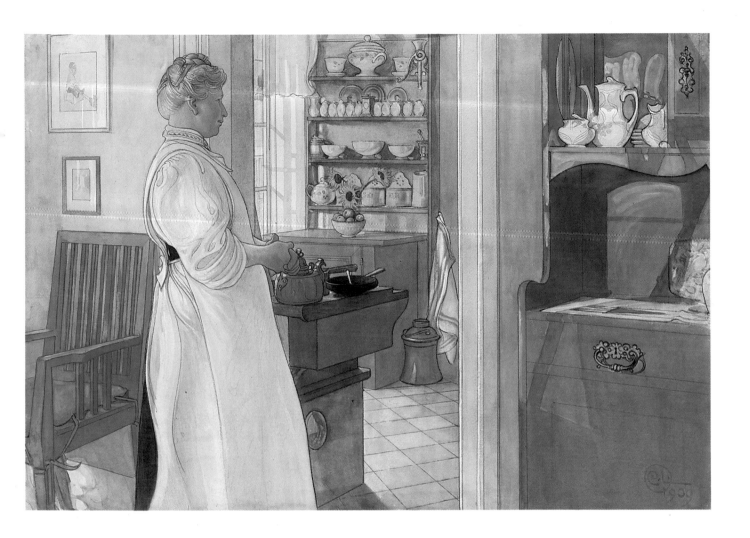

Carl Larsson
Anna Arnbom 1909
Watercolor on paper
51.7 x 73.7 cm. (20⅜ x 29 in.)
Published in *Åt solsidan*, 1910
[Collection: Mr. and Mrs. Arthur G. Altschul, New York]
Cat. no. 41

Anna Arnbom was the daughter of the Sundborn cabinetmaker Hans Arnbom, who did much of the work in Larsson's house (see cat. no. 52). She looked after the children when they stayed at the house in Falun during the school year and is seen here in the house's dining room, looking into the kitchen. As in many of the Åt solsidan pictures, in keeping with the theme of the series, Larsson shows a particular interest in the play of sunlight as it comes through a window and falls on reflecting surfaces creating highlights and patterns of light and shadow. These light effects are never used in an Impressionist way to dissolve form but serve as a further source of linear shapes to play against the objects in the room. Like Karin's figure in Karin by the Shore (p. 6), the figure of Anna is placed at the left of the picture on the front plane, dominating the space depicted in the manner of an informally posed portrait study.

years were clouded by attacks on his authority as a painter, and the rejection of *Midwinter Sacrifice* in particular hurt him deeply. This, together with such personal sorrows as a debilitating eye disease and the loss of his eldest son in 1905, left him once again feeling the bitterness and despair of his youth as he strove to maintain the illusion of an unfettered happiness.

The very title of Larsson's last book of watercolors, *Åt solsidan (On the Sunny Side)*, published in 1910, indicates that at the end he wanted to chase away the shadows. When his autobiography was published in 1931, twelve years after his death, the myth of his unclouded happiness was finally exploded. With this book, simply and characteristically entitled *I*, Swedes came to know a new Carl Larsson— unstable, thin-skinned, fragmented, and self-obsessed. He there unclothed himself in all his naked frailty, emerging as a complicated human being, but also as an artist with a touch of genius.

Cat. no. 90

The national institution that Carl Larsson continues to represent in Sweden more than sixty years after his death is based not only on what and how he painted but also on what he in the broadest sense symbolized. Here was a man with two of the most common Swedish names who had worked his way up from poor, not to say utterly wretched, circumstances to become an internationally renowned artist. Despite his success, he never became rich—which, in the Swedish context, was to his credit—and he never let fame go to his head, retaining lifelong an unaffected, unconventional, and spontaneous personality. He had a beautiful, gifted wife, countless friends, and a large, and in the public mind happy, family. He was the very personification of contentment—a self-made man who seemed totally at peace with himself and the world.

No aspect of Larsson's life has done more to reinforce this public image of the artist than his home at Sundborn in the province of Dalarna. In Sweden, a recently industrialized nation where most of the population is only a generation or two removed from the land and still retains a romantic enthusiasm for nature, every self-respecting citizen wants to own a little red-and-white country cottage under the birches by the glittering water—a place to enjoy the ardently awaited spring and summer. Having realized such a country home, Larsson and his wife Karin threw open its doors and announced to the world (in words that are painted above the home's entranceway): "Welcome to this house, to Carl Larsson and his spouse." Thanks to the five volumes of watercolors in which Larsson documented every fascinating nook and cranny of this light and airy realm of domestic bliss, Little Hyttnäs, as he called it, has become the ideal home—one is tempted to call it the national home—of generations of Swedes, as beloved today as it was at the beginning of the century. There may be more famous or more imposing artists' homes from the turn of the century, but as the Swedish writer Eva von Zweigbergk has noted, "It is only in Carl Larsson's home that everyone sees the reflection of cheerful everyday life, of the eternal human dream of work, love, health, happiness, friendship, trust, gaiety, success, family feeling, and natural development."

It is no accident that the vision of the good life that Larsson symbolized found its strongest expression in his home at Sundborn, for Larsson considered the home his "work of all arts." While it is perfectly legitimate to evaluate and weigh against each other his contributions as a painter, draftsman, engraver, illustrator, and author, the unique thing about his oeuvre is its remarkable totality—and in this his home plays the central role. As a visual artist Larsson never founded a school, but as the creator of a home he became—together with his wife—the incomparably most important artistic influence in modern Sweden.

Ironically, in encouraging the notion that a private house with all its furnishings might be viewed as an integrated artistic expression, Larsson, the most Swedish of all artists, was using his ideal Swedish home to promote ideas which were, in fact, international in scope. An acknowledgement of the moral and aesthetic importance of the decorative arts, a belief in simplicity of form and honesty of craftsmanship—these were important tenets of progessive art in late nineteenth-century Europe. And yet Larsson combined them so effortlessly with native decorative traditions that, even if there is comparatively little in his home which can be called genuinely Swedish, he was seen as defining the national style.

In returning to Sweden from Paris in 1885, Larsson was responding to the desire of cosmopolitan Nordic artists to make an art rooted in their native land. Part and parcel of this so-called National Romantic movement was the impulse to leave the city and settle in the country, where, it was believed, much could be learned from the vanishing *volk*. Like many of his Scandinavian colleagues, Larsson felt that artists should not only be trained in the painting of pictures but should also learn more practical crafts. In

The Ideal Swedish Home

Ulf Hård af Segerstad

Doctor of Philosophy, Stockholm

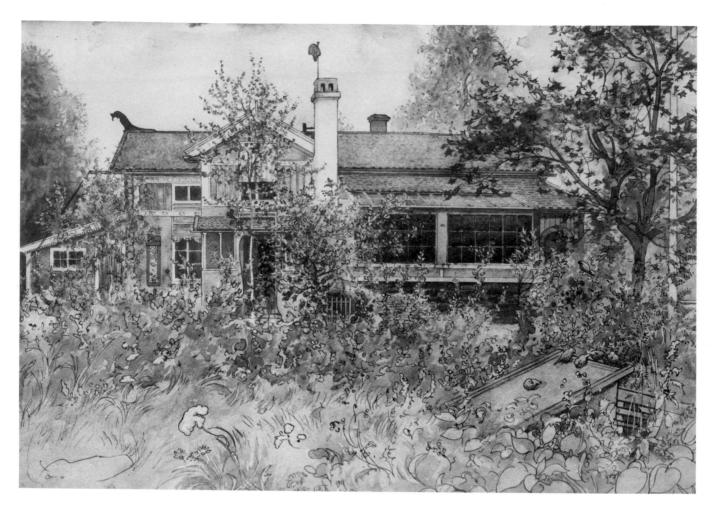

Carl Larsson
The Cottage *circa* 1895
Stugan
Watercolor on paper
32.0 x 43.0 cm.
(12⅝ x 16⅞ in.)
Published in *Ett hem,* 1899
[Nationalmuseum, Stockholm,
Sweden]

1889, during a visit to the World Exposition in Paris, he wrote home to a friend that he wanted to stimulate the younger generation of artists to "go out and preach to all the people the fair and joyful message of art...to tell them: creep into all corners, into the roofs of both the mighty and the humble, dropping into their eyes and hearts a yearning for pleasing colors and delightful shapes; carve stoops and staves, make doors and cupboards, storm the china factories and drive out the Germans with their dull Lutheran art and Lutheran religion, and learn to love the glorious material, blow glass into fantastic shapes, climb up the walls and arouse the engineers, hypnotized by the Academy, who call themselves architects. Yes, painter, build the houses yourself, if your imagination has not been killed by all that tracing of monuments that the architects believe themselves at least capable of imitating."

Cat. no. 85

That same year Larsson got a chance to put these ideas into practice when he and Karin inherited the house at Sundborn from Karin's two aunts through the mediation of her father, a well-off man of business. This house, a quite ordinary log cabin of two rooms and a kitchen with attic space above, was, as Larsson described it, lying bare on a former slag heap, surrounded only by a few hardy dwarf birches, a few lilacs, and a potato patch. "But I called it my own," he added, "and off and on, and with small extra savings, Karin and I, with the help of the village carpenters, blacksmith, bricklayer, and painter, did it up, a bit here, and a bit there."

The Larssons' method of enlarging their home—adding room after room to the original building so that the house appears to be taking a walk around the site—was English, and Little Hyttnäs is one of the earliest examples of the international influence of English ideas about the construction and renovation of rural cottages. The first major addition to the house, a studio built in 1890, was placed along the western side of the house, beside the entrance hall and in front of the dining room and the drawing room, the windows of which were left facing onto it. A remarkably large open fireplace provided heating, and its tall white English-type chimney lent a picturesque touch to the exterior. For fairly obvious reasons this studio failed to provide the privacy Larsson needed to paint, and in 1900 he added a larger, free-standing studio set at an angle to the northern end of the house. The earlier studio was then converted into a sort of family room called

Vignette from *Ett hem* (1899) showing the farmhouse as it was in 1889 when Larsson acquired it. The log cabin construction was typical of traditional Swedish farm buildings.

Carl Larsson
The Cottage in the Snow 1909
Stugan i snö
Watercolor on paper mounted on canvas
63.0 x 96.0 cm. (24¾ x 37¾ in.)
Published in *Åt solsidan*, 1910
[Collection: Turku Art Museum, Finland]
Cat. no. 42

This picture might have been made as a conscious pendant to The Cottage *in Ett hem (see illustration on p. 40), which shows the west front of the house in high summer. Here in midwinter the viewpoint has been angled northwards so that part of the studio wing added in 1901 can be seen. This wing, with its stuccoed wall, wide window, and dark wood trim, is distinctively English in character and reflects the Larssons' familiarity with the cottage and bungalow designs by Voysey (see illustration on p. 45), Baillie-Scott, and others published in* The Studio *during the 1890s. When the new studio was built for Larsson, it freed the former studio (see cat. no. 16) for a workshop in which Karin could weave and design furniture. The composition here is dominated by the large area of snow, deep and somewhat creamy-looking but sharply observed in the way that the drifts swoop and curl on the roofs.*

the workshop, where Karin could sit and sew or weave and the children do woodwork or play. In 1901, when the Larssons, who had previously spent the winter half of the year in Stockholm, moved to Sundborn for good, an old woodshed on the northern side of the house was pulled down and a two-story extension of the original cabin built in its place. This extension, which connected the main building with the newer studio, housed on the ground floor a pantry, a washing room, a maid's chamber, a boy's room, and a bathroom; on the upper level was a guest room—the so-called Old Room—and a room for the eldest daughter, Suzanne. In 1912 the family bought from a nearby village an old miner's log cabin decorated in the provincial style with peasant paintings on its

Carl Larsson
Title Page of "Åt solsidan"
Albert Bonniers
Förlag AB, Stockholm,
Sweden, 1910

This watercolor
depicts Hans Arnbom
and another craftsman
at work in the
Sundborn sitting-room.
*Photograph courtesy
The Metropolitan
Museum of Art,
New York.*

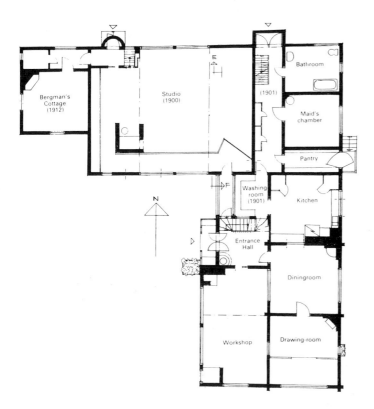

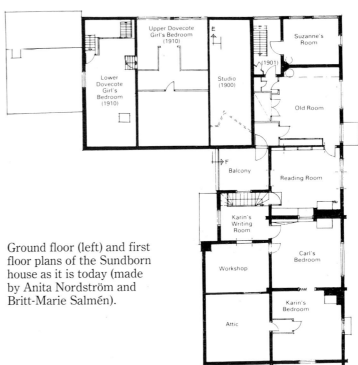

Ground floor (left) and first
floor plans of the Sundborn
house as it is today (made
by Anita Nordström and
Britt-Marie Salmén).

walls. While this cabin, which the Larssons called Bergman's Cottage, was attached to the newer studio, two dormitories, which the family referred to as the upper and lower dovecotes, were built in under the studio's high roof to serve as summer rooms for the children.

The ideas which influenced the Larssons' design aesthetic derive their sense ultimately from the Englishmen William Morris and John Ruskin. Morris, an artist, had originated the idea of the "artistic house." His "Red House," built by the English architect Philip Webb in 1859-60, demonstrated the virtues of honest craftsmanship and simple, integrated interior design. Ruskin praised Morris's work, stressing the ability of the architectural environment to better the lives of human beings. Together, they inspired the Aesthetic Movement of the 1870s and '80s and the Arts and Crafts movement of the 1890s. The Larssons were deeply committed to both these movements and by travelling widely (Karin often visited London to see her sister) they stayed in touch with the newest ideas, which apart from specific visual elements included the injunction to return to native roots: in England to the yeoman's cottage, in Dalarna to the wooden house with its figured walls and tile stoves.

It is, however, difficult to pinpoint exact sources for the style of building and decoration at Sundborn. The importance of the English periodical *The Studio,* to which the Larssons subscribed from its inception in 1893, is often cited, and indeed in the mid- to later '90s and after there appeared a number of articles in *The Studio* which published cottage designs and interiors by such figures as Charles Annesley Voysey, M.H. Baillie-Scott, R.A. Briggs, and Charles Rennie Mackintosh. While these articles can be readily related to the cottage and interior design at Sundborn, much of the work there had been completed between 1890, when the first studio was added, and 1895-96, when the exterior and interiors were depicted in the twenty-four watercolors in *Ett hem.* Thus

C.F.A. Voysey
"The Orchard"
Chorley Wood, England
Illustrated in *The
Studio Yearbook,* 1901

Sitting room window in the Larsson house at Sundborn.
The wide bay window in the English style was installed in
the early 1890s (see p. 57); the room-wide platform with
railing was built after 1900. *Photograph courtesy of Studio
Granath, Stockholm, Sweden.*

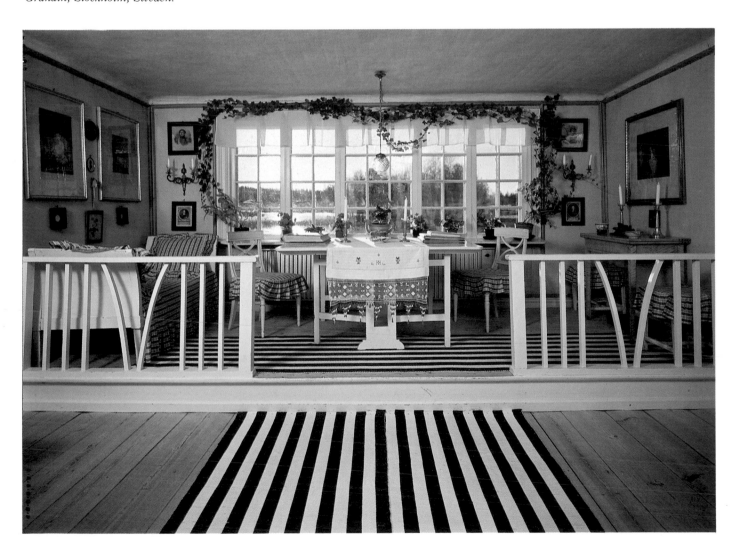

although *The Studio* was certainly an influence in the additions to the house after 1900, the original work at Sundborn must be considered as coming out of the same body of ideas which also stimulated the architectural generation of the nineties in England. For example, all of the features of the Larssons' drawing room, including the light walls with their painted decorations and the very English wide and deep window bay with the raised platform in front of it, were in place before 1894-95. It is only in the changes that were made to the room after 1900, when the platform was extended and the white railing built, that we may see a direct affinity to a design such as that of Voysey's staircase at Hans Place, Chelsea, which was published in *The Studio* in mid-1894.

But no matter what the sources of inspiration were, the important thing is the undeniable individuality and atmosphere of the end result. In its reflection of the age's National Romantic passion for old objects, the last addition to the house, Bergman's Cottage, might seem, for instance, to be somewhat out of place. Yet it was, on the other hand, part of the Larssons' attitude toward the "things around us" to unashamedly blend the old and the new, things foreign and Swedish, expensive and cheap, with no consideration to the prevailing conventions of good taste or indeed to what was beautiful or ugly. In this respect they were superbly independent forerunners of the more liberal view of a later age.

During the patriarchal era in which the house took shape, it was naturally regarded as Carl Larsson's work, and his alone. Although attention was accorded to many details of the furnishings which were on occasion ascribed to Karin, it was essentially the master of the house who took the credit for the overall impression. Now, in the age of Women's Liberation, we are more inclined to apportion recognition more justly between

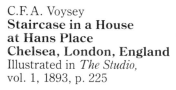

C.F.A. Voysey
**Staircase in a House
at Hans Place
Chelsea, London, England**
Illustrated in *The Studio,*
vol. 1, 1893, p. 225

husband and wife, and there is even a tendency to credit Karin with details of the interior decoration on no more specific grounds than that they seem of assured taste and are of a sensible housewifely practicality. And yet the fact remains that when she met her husband Karin Bergöö was a painter with four years at Sweden's Royal Academy of Fine Arts behind her. Although she had abandoned painting to devote herself to the role of wife and mother, she continued to exercise her considerable talents. During those periods when the house was in a more or less constant process of conversion and Carl was out on his long and numerous travels, she alone oversaw the work of the carpenters and painters. It seems reasonable therefore to ask to what extent the ideas applied were hers.

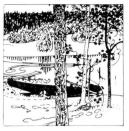

Cat. no. 84

Unfortunately, it proves extremely difficult to specify Karin's contributions. It is known that she drew and commissioned from Hans Arnbom, the local carpenter, a low solid table, a simple rocking chair, a tiered table for flowers (see below), and a couple of beds for the children. The first three items are rustic and pre-Functionalistic in a manner that recalls the furniture of the Vienna Secessionist Josef Hoffman. The rocking chair, which Arnbom thought so clumsy that he delivered it at night, has been described in some quarters as almost sensationally progressive. But the models were there in the international literature, and right-angled sugar crate furniture of the do-it-yourself type was popular at the time. A copy of the American Louise Bingham's book *Box Furniture,* dedicated to the Larssons and their "home of all homes," is in the Sundborn library, and it is possible that Karin took her inspiration for the flower stand from this source.

Karin's greatest contribution to the creation of the home was as a textile designer. To what extent she discussed her work with her husband we simply do not know, but the bed curtains in his bedroom, with their exquisitely simple design, are essential to the superb artistic wholeness of the room, as are the justifiably praised loose-woven hang-

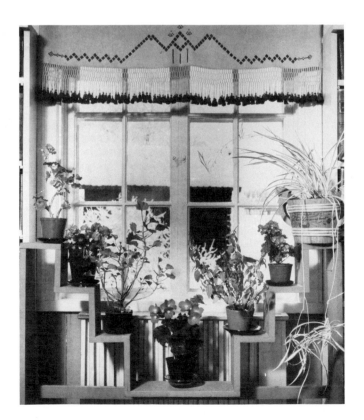

Box-shelf in the upstairs hall in the Sundborn house designed by Karin Larsson. *Photograph courtesy of Studio Granath, Stockholm, Sweden.*

47

Carl Larsson
Home's Good Angel 1909
Hemmets goda ängel
Watercolor on paper
51.0 x 73.0 cm. (20⅛ x 28¾ in.)
Published in *Åt solsidan*, 1910
[Private collection, Sweden]
Cat. no. 40

During his years as a prolific illustrator for books and magazines, Larsson had invented many imaginary figures, whether fictional or allegorical. But as he turned in the 1890s to illustrating his own life, such figures had no place. An exception is this image of a decidedly feminine angel standing in the bedroom that had been decorated for Karin and the youngest children in 1894 (the other side of this room is shown in Brita's Nap, p. 16). This unusual fact, together with the title of the picture, makes it possible to speculate with some validity that Larsson may have had in mind the well-known and very popular narrative poem sequence by the English poet Coventry Patmore, The Angel in the House. *Published in 1854-56, it had become a best-seller by the time of Patmore's death in 1894. Patmore's religious devotion to marital and parental love, and his idealization of the wife and mother, would have had enormous appeal to Larsson. Even if he had not read the book—which, since he read English, he could have done—the title phrase had by this time entered the language. Certainly it expressed the ideal which Larsson saw in his wife Karin. Like many of the other pictures in* Åt solsidan, *this one emphasizes the light of the sunshine that floods the room. By 1909 the youngest child was a boy of nine; the baby toys on the floor are a reminder of the past.*

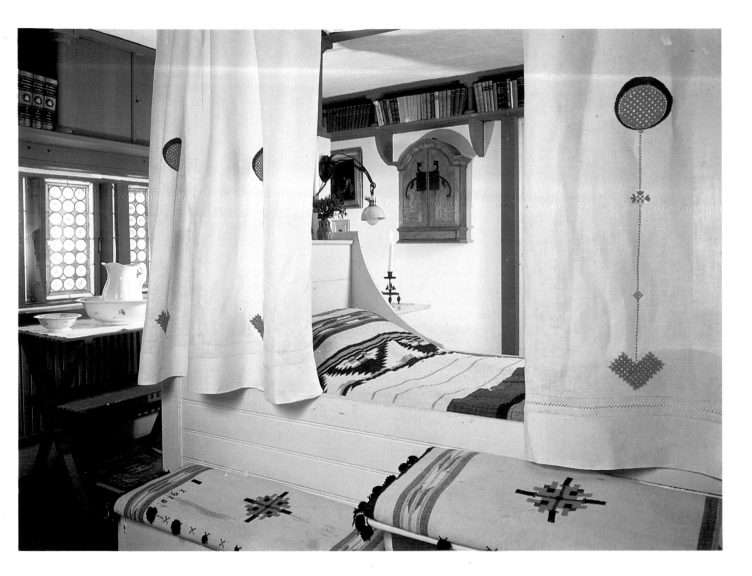

Father's bedroom in the Larsson house at Sundborn. The carpenter-built bed was made in 1890; the embroidered bed hanging and the woven coverings on the bed and chests were designed and made by Karin Larsson after 1900 (one chest-cloth is dated 1912). *Photograph courtesy of Studio Granath, Stockholm, Sweden.*

ings in her own and the children's rooms. Among her most impressive creations are the Navaho-inspired "Sundborn blanket" on Carl's bed, the dramatic 1918 dining room cushion cover ornamented with symbols of the war, the sparsely decorated white table-cloths done in lockstitch with bright red cotton yarn, and a tapestry named *The Four Elements.* In general these works associate to the apparatus of forms presented in *The Studio*, in which Baillie-Scott in particular published articles prescribing rules for the appearance of embroideries and other textiles. But we can also trace influences from the Vienna Secessionists Josef Hoffman and Joseph Maria Olbrich, who employed simple right-angled shapes and a color scheme of green, pink, yellow, and above all white.

While both Karin and Carl Larsson were concerned with designing the good, the essentially human, environment, they realized that the people who frequented their

home were more important than the home itself. In spite of the shadows that fell over certain periods of their life—the object today of self-congratulatory speculation—they succeeded in spreading around themselves a unique aura of friendliness and charm. To this I can testify, for my parents brought me to Sundborn several times during my early childhood. On a winter day in 1918 Larsson did an etching of me called *Grandfather's Sword* in which I am shown shyly holding the sword's scabbard. Since that day I have never lost contact with Sundborn and the fates of the immediate or more distant family. I am still feeling the spell of Carl Larsson's enchanted world.

Carl Larsson
Papa's Room *circa* 1895
Pappas rum
Watercolor on paper
32.0 x 43.0 cm. (12⅝ x 17 in.)
Published in *Ett hem*, 1899
[Collection: Nationalmuseum, Stockholm, Sweden]
Cat. no. 17

As in so many of the watercolors in Ett hem, *the same brilliant simplicity of color and line characterizes both the subject—the red and white bedroom—and its depiction. All of the furniture and fittings here—not only the canopied bed but also the moldings and of course the shelves that act as a decorative frieze along the top of the walls—were designed by the Larssons and built by the local carpenter. At the time of this painting, the bed-hangings were made of locally embroidered cloth; some time after 1900, when the Larssons lived at Sundborn year round and Karin was able to devote time to designing and making textiles, bed curtains of her own in a distinctive contemporary design were installed (see illustration on p. 49).*

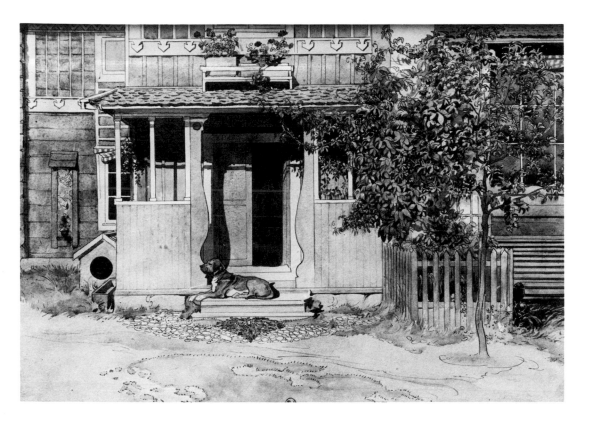

Carl Larsson
The Verandah *circa* 1895
Verandan
Watercolor on paper
32.0 x 43.0 cm. (12⅝ x 16⅞ in.)
Published in *Ett hem*, 1899
[Collection: Nationalmuseum,
Stockholm, Sweden]
Cat. no. 19

*This painting focuses not only on the front door of the house,
with its welcoming motto over the door, but also on the
additions which had been made to the house in 1890-91. The
window at the right is the long window of the studio across the
west front (see cat. no. 16). The white band behind the
shrubbery is the stuccoed, English-style chimney; in the middle
is the entrance porch, which was built onto the projecting wing
of the original cottage. The simple, pedestal-like curves which
flank the central opening soften the strong rectilinear emphasis
of the building and its wall treatment. In its play of folk-based
geometric motifs in white against red—its strong feeling for
color, interval, and pattern—this little facade is characteristic of
the Larsson sensibility.*

Cat. no. 94

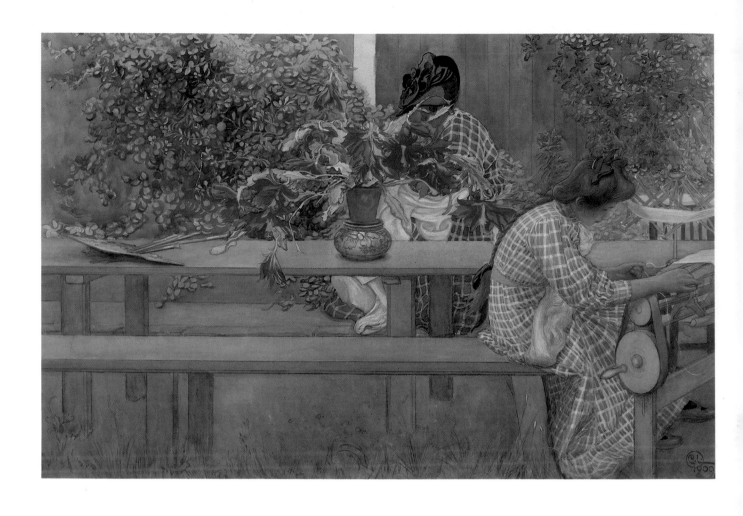

Carl Larsson
Karin and Brita with Cactus 1909
Karin och Brita med kaktus
Watercolor on paper
76.0 x 112.0 cm. (29⅞ x 44⅛ in.)
[Private collection, Sweden]
Cat. no. 43

*Seated at the wooden picnic table outside their house, Brita
winds hanks of knitting wool while Karin appears to do
needlework behind the fiercely blooming cactus plant at the
center of the picture. While Larsson used knitting or sewing
materials to indicate Karin's absence, he here places palette
and brushes on the table as emblems of his own presumably
superior, supposedly masculine calling. Yet despite this
patriarchal attitude, he believed in the importance of beautiful
well-made objects of everyday use and respected the artistic
talents that produced them.*

Carl Larsson's 1907 oil painting *Now it's Christmas Again* owes its name to the best known of all Swedish Christmas carols and, like the carol, aims at being a merry contribution to Christmas celebrations. Consequently the painting has become something of a Swedish classic; it is almost as if the dinner party on Christmas Eve in Sweden attained its canonical form with this work. The picture (see pp. 54-55) displays nearly everything a Swede could dream of at Christmas dinner: an abundant smorgasbord; the Virgin Mary with the Holy Child; and guests dressed up in Dalarnan costumes, considered by most Swedes as being the most genuine manifestation of Swedish national character.

But the hosts themselves are not sharing the enjoyment of their guests. Mrs. Karin Larsson constrains herself in order to supervise the party; like a blue-uniformed field marshal she ensures that it proceeds according to a set plan. Light-years away from her, in the opposite pole of the painting, Mr. Larsson has turned his back on the crowd and is staring at the ice-bound windows of his studio, unable to see through them.

Having detected the artist's lonely, shadowy figure behind the Christmas tree, one may get the feeling that the happiness in *Now it's Christmas Again* is artificial, even false. And for a Swede, this is quite an alarming experience. If anything is generally accepted without question in Sweden, it is the happiness of Carl Larsson and his family in their beloved home at Sundborn in Dalarna.

So why does Carl radiate alienation, perhaps even misery, on Christmas Eve, the happiest day of the year? And why is Karin neglecting her depressed husband? Contemporary observers maintained that her love for him was deep, rare, and genuine. She was looked upon as a model wife and mother, both pitied and admired because she had sacrificed her own artistic career in order to create the happy family life Carl immortalized. He, in turn, thanked this "good angel" of his life with overflowing declarations of love, culminating in the last words he wrote before his death: "I am not afraid: I have loved" (Larsson, 1931). Yet every great emotion houses its opposite, and although Carl loved his Karin and the home she created for him, he sometimes also felt imprisoned by her. She was not only his "good angel" but occasionally also his warder.

Karin was born in 1859 to the Bergöös, a wealthy merchant family with its roots in Sundborn. Her parents soon discovered her artistic talents and permitted her to develop them. In 1881 after finishing her studies of painting at the Royal Academy of Fine Arts in Stockholm, she left for Paris and was accepted as a student at the Academie Colarossi. During the summer of 1882, while working in the village of Grèz outside Paris, she met Carl, who began to court her by placing his easel next to hers and adopting her motifs in his watercolors.

In his autobiography *I*, published posthumously in 1931, Carl describes how painting with Karin turned him into quite a different person and a new artist. Since very few of Karin's own paintings have been preserved, it is difficult to evaluate the exact degree of her influence on Carl. In moving to Grèz, both of them were responding to the *plein-air* Naturalism of Jules Bastien-Lepage. Yet Carl seems to have kept his taste for literary, often sentimental motifs in the early Grèz pictures he painted before he met Karin, while Karin herself was never literary or sentimental. It therefore seems likely that Karin's main contribution to the "new" Carl Larsson was to liberate him completely from his immature, late-Romantic provincial imagery.

Karin wrote to her parents from Grèz that never before had she met a person who gave her such support as Carl Larsson. With well-mannered modesty she added: "Previously I never thought I would come to play any role in this life. I thought I was merely a subordinate character, that I was made to serve as a background for other

Karin and Carl Larsson

Madeleine von Heland

Professor of Cultural History, University of Stockholm

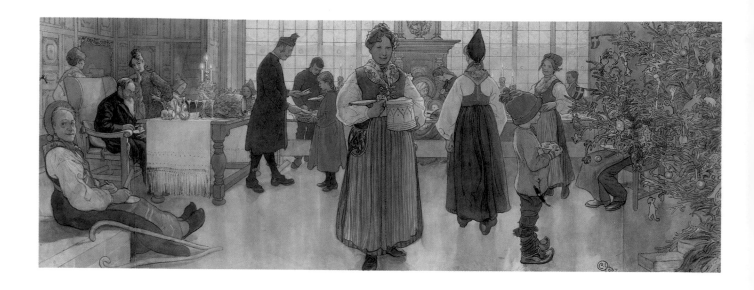

Carl Larsson
Now It's Christmas Again 1907
Nu är det jul igen
Watercolor on paper
56.0 x 146.0 cm. (22 x 57½ in.)
[Collection: Mr. and Mrs. Arthur G. Altschul,
New York]
Cat. no. 35 (*above*)

*This watercolor version of the same composition as cat. no. 34
differs from the oil only in detail: the shift in placement of the
woman's figure at the far left; the removal of the decorative
hanging in the paneling at the left rear to reveal the steep
staircase; the substitution of a child for a woman behind the
figure of the minister; the absence of the fireplace and the
chair with the violin on it; and, perhaps most significantly, the
removal of two of the figures— including the artist himself—
from the right rear.*

*Less crowded and executed in the medium Larsson knew
best, the watercolor is the more assured and unified of the two
works. It is not possible or even necessary to say which was
made first, since the watercolor was painted as an independent
work, not as a study for the large oil. Both were composed of
the same elements, but not in any functional relation to one
another.*

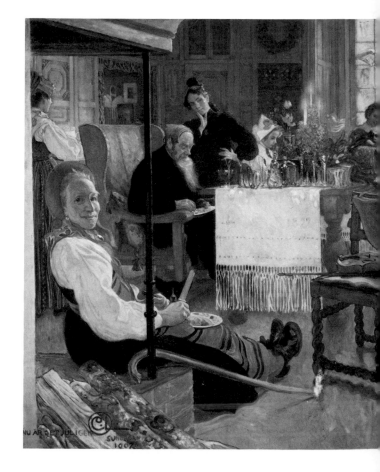

Just as the Nordic Midsummer Night is a celebration with roots deep in the pagan past, so the winter Christian festivals of light—Christmas and the mid-December St. Lucy's Day—have a long tradition in Scandinavia. The mood of National Romanticism at the turn of the century stimulated an increased awareness of the folk origins and attributes of these festivals, and the Swedish province of Dalarna was particularly rich in folk traditions and decorative arts that came to be associated with the essentials of the Christmas celebration—an association that this painting reinforced.

The setting of this Christmas feast is the new studio that had been added to the Larsson house in 1901. It is the largest space in the house, though not so large as it is made to seem in this monumental triptych. The figures are family members and friends: Karin standing by her father-in-law at the head of the table; the family cook Anna Arnbom in the center; Esbjörn, the youngest child, in the red cap; and at the right rear by the window the artist himself, gazing out at the snow. Hanging from the Christmas tree, directly above Larsson's head and at his elbow, are two little Swedish flags—clear signals, if any were needed, of his passion for the Swedish folk tradition that informed both his love of Sundborn and his decorative style. Behind and to the·right of the central figure in the painting is a motif taken directly from Pieter Bruegel the Elder's Peasant Wedding: the unobtrusive presence at the family festival of the Virgin Mary, here with the Christ Child.

Carl Larsson
Now It's Christmas Again 1907
Nu är det jul igen
Oil on canvas
Triptych, overall 178.5 x 455.0 cm. (70⅛ x 179 in.)
[Collection: The Helsingborg Museum, Sweden]
Cat. no. 34 (below)

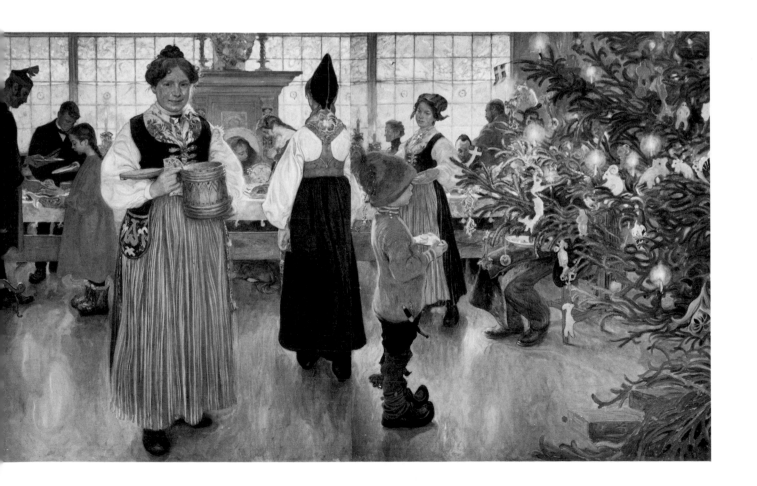

characters, so that they could be better seen.'' But if she believed that Carl would continue to support her artistic career after their marriage, she deceived herself pitifully, for her fiancé did not believe in the capacity of women to become independent artists. Throughout his life he never missed an occasion to express his opinion that the true role of woman was that of mother and housekeeper (Larsson, 1907), and he opposed the inclusion of women in academic artistic training (Nordensvan, 1920).

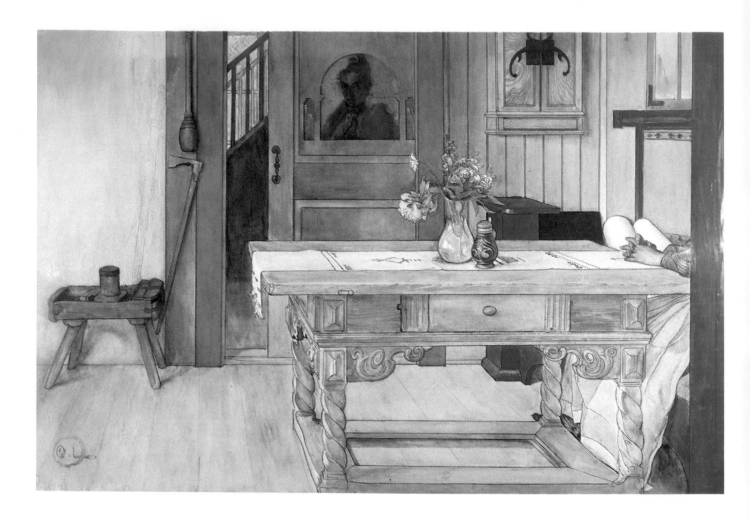

Carl Larsson
Sunday *circa 1898*
Söndag
Watercolor on paper
68.0 x 104.0 cm. (26¾ x 41 in.)
Published in *Larssons*, 1902
[Collection: Nationalmuseum, Stockholm, Sweden]
Cat. no. 20

This painting is undated but appears to be from late in the decade, based on its placement in the roughly chronological sequence of the pictures in Larssons. *Although it is similar in style to the* Ett hem *watercolors, the scale is much larger than the paintings in that series. The vertical bands of saturated red and blue-green are elegantly set off against pale shades of gray and tan. (The door frame has been painted since this corner*

was depicted in The Studio, *cat. no. 16.) Larsson was fond of implying absent personalities by their possessions; here his wife Karin is seen in a strangely fractured way: her folded hands and skirt appear at the right, while her simulacrum, the face painted on the studio door, gazes out from the center of the composition. As is often the case, Larsson's "story" of the picture—Karin had stayed home for a little peace and quiet while the family went off to church—is far less evocative than the image.*

Thus it is not surprising that soon after her marriage in 1883 Karin chose to stop painting. Instead she developed other creative faculties, all centered on the Larsson home and family. Inspired mainly by contemporary English textile and furniture design, she created the "Carl Larsson Look"—ample billowing clothes in the style of Art Nouveau, light and brightly colored interiors, rustic furniture, and consciously wild-grown flowerbeds that formed a resplendent frame around the house in

Carl Larsson
Flowers on the Windowsill *circa* 1895
Blomsterfonstret
Watercolor on paper
32.0 x 43.0 cm. (12⅝ x 17 in.)
Published in *Ett hem,* 1899
[Collection: Nationalmuseum, Stockholm, Sweden]
Cat. no. 14

This is perhaps the most widely published and familiar of the pictures in Ett hem. *It depicts the outside wall of the Sundborn sitting room, also called the drawing room or the flower room on account of the window filled with flowering plants. This horizonal or "bay" window, which occupies almost the full extent of the wall, looks out upon the bend in the Sundborn River at the edge of which the house is built. The window was one of the specifically English, Queen Anne*

Revival elements that the Larssons incorporated in their house, and its wide expanse allowed the room to be flooded with light in a way that had become newly desirable to innovative designers of the later nineteenth century. As in Lazy Nook *(p. 58), the device of implied presence is seen in the empty chairs and abandoned knitting. The size of the chairs and table, the way they dominate the center space, and the manner in which they are cut off at the front of the picture plane are all reminiscent of the distorted perspectives of a photograph. Though no evidence exists that Larsson made specific use of photographs in his paintings of interiors, he would certainly have been familiar with photographic images. The "wide angle" perspective that he used in most of his interior drawings permitted him to include more detail than could have been captured with an ordinary perspective.*

Sundborn. It was as a textile artist that she developed her greatest originality, and about seventy textile works by her hand are known. Although most of them are executed in web-bound embroideries, there are also examples of free embroideries and tapestries. Her patterns have been characterized as consciously symbolic, sometimes highly original, sometimes influenced by contemporary British and Scottish works (Andersson, 1980).

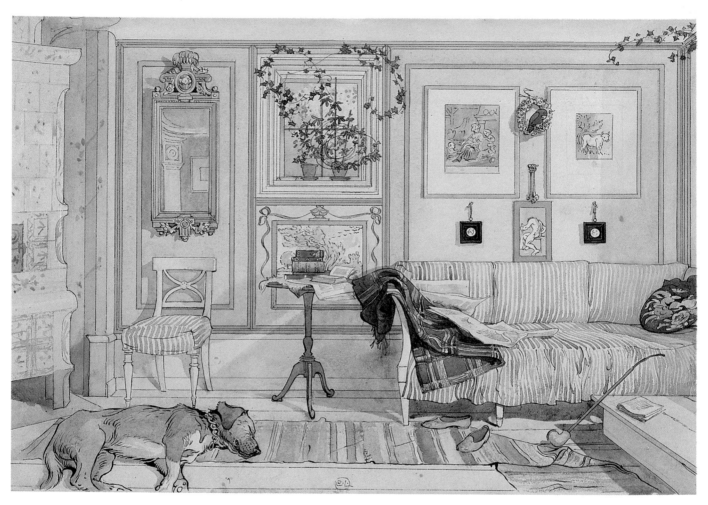

Carl Larsson
Lazy Nook *circa* 1895
Lathörnet
Watercolor on paper
32.0 x 43.0 cm. (12⅝ x 17 in.)
Published in *Ett hem*, 1899
[Collection: Nationalmuseum, Stockholm, Sweden]
Cat. no. 13

Pictured here is the side of the sitting room opposite that seen in In the Corner *(p. 20). Though human figures are absent, the presence of the* paterfamilias *is implied by the blanket, the newspaper, the slippers, the pipe, and the book. Behind the little table under the high window Larsson has painted a* grisaille *landscape in eighteenth-century style. To the right at*

the window another example of his eighteenth-century taste is seen in the engraving of Silence! *(or* The Happy Mother) *by Jean Baptiste Greuze. This image of a busy mother hushing one child so the baby on her lap may sleep, while a third child looks on, had been popular since its first issue shortly after the painting was made in 1759. Its presence in the Sundborn house relates both to the French provincial atmosphere of this room in particular, and to the affinity between the themes of bourgeois domesticity in late eighteenth-century French art and Larsson's own ethos. The tile stove so lovingly depicted in cat. no. 10 is here only sketched in. These country stoves had gone out of fashion earlier in the century, and it was a significant aspect of Larsson's modernity that, as in the case of the peasant wall paintings of Dalarna, he saw their quality and rescued this example from destruction.*

In his picture book *A Home* (1899), Carl openly admitted that the famous Sundborn watercolors originated in Karin's suggestions. "Well, frankly speaking," he wrote, "it was really Karin's idea." And when Carl celebrated his sixtieth birthday, the famous Swedish author Elin Wagner stated that it was Karin who should be praised for the Sundborn pictures, in which Swedes had recognized their own ideal home. Karin, he said, had not only brought art into the home but also the home into art (Wägner, 1913).

Karin's talent in creating small scenes of everyday life for Carl to depict is made evident in one of her 1889 letters to him. "Suzanne helped mother to bake all day yesterday," she wrote. "I found that my baking dress suited me so well that when you come home, I shall have to make bread often in order to show off to you. Clean cotton dress, white apron, white head-cloth and a touch of flour on the nose. The flour on the tip of the nose is of utmost importance" (Frieberg, 1967). Although Carl never painted this scene, nothing is simpler for anyone acquainted with his pictorial world than to imagine him transforming such a motif into a watercolor. In fact it is quite easy to see Karin's tasteful hand behind most of the Sundborn pictures. Interior decoration and dressmaking are creative niches for women all over the world, and by documenting these types of female activity the Sundborn watercolors suggest that what Karin lost in an independent artistic career by marrying Carl, she learnt to make up for by proving a source of inspiration for him. It might even be said that she sometimes used him to realize her visionary world. Thus her artistic career did not come to an end with her marriage, as has often been maintained. Instead she resounded in him and created settings for him to document.

Karin's extraordinary influence on her husband is best documented by Carl himself. In an 1882 letter to his Stockholm publisher Albert Bonnier, he described her as his soul, and twenty-five years later on the occasion of his sixtieth birthday he pointed to her as the leading star of his life in a photograph published by the weekly magazine *Idun*. As the Swedish art historian Bo Lindwall has noted. "It was his wife who created around him the harmonious surroundings he spent his whole life documenting. What she meant for him in terms of sacrificing herself, smoothing the road, clearing away obstacles, stimulating and giving encouragements, we can now

Cover of the Stockholm weekly magazine *Idun*, special number for Carl Larsson's sixtieth birthday in 1913.

Carl Larsson
Little Suzanne 1885
Ink on paper
34.6 x 23.5 cm. (13⅝ x 9¼ in.)
[Collection: Nationalmuseum,
Stockholm, Sweden]
Cat. no. 55

This ink drawing is a replica, close in every detail, of an oil
painting of the same year now in the Gothenburg Art Gallery.
Like Interior with Karin Reading *(cat. no. 5), it is one of the*
relatively few private domestic themes that Larsson painted in
the 1880s when he was still working in a Naturalist style. We
see the figure of Karin cut off at the right, essentially a
support for the first-born infant who is the focus of the picture.
Of equal importance to the composition are the surrounding
props and furnishings: the eighteenth-century engraving and
the floral textile on the wall, and the sword, the slippers, and
the Japanese doll—one of a number of Japanese artifacts that
appear in Larsson's interiors.

Carl Larsson
Bizzarerie 1885
Published in the catalogue of the 1885
"Opponents" exhibition in Stockholm which
was called *From the Banks of the Seine.*

60

only vaguely perceive" (Lindwall, 1953). According to Karin's biographer and son-in-law Axel Frieberg, she was the supreme judge of his work, and he never signed a painting until she had approved of it.

Carl was aware of his dependence on Karin and at least subconsciously often plagued by it. Over and over again he filled his portraits of her with scissors, knives, and needles, as if she wanted to cut, stab, or prick him to death. The ambivalence that he felt toward her and the children can be seen in a comparison of two of his earliest portrayals of the family—*Little Suzanne* and *Bizarrerie*, both from 1885. According to the artist himself he painted *Little Suzanne* in order to express his newly won matrimonial happiness (Larsson, 1902). Yet in *Bizarrerie* the baby girl is largely concealed behind a tambourine, the thin membrane of which she is dashingly kicking to pieces. Among her "toys" are a dagger as big as she, a split pomegranate, a folded fan, and a jawless skull. A lit candle stands behind the skull, and in the dark shadow of the tambourine lurks a sly male face of the sort that might be hiding under the bed or in the cupboard, ready to scare someone afraid of the dark.

Had Carl continued to depict his children in such a morbid way, he would never have gained a reputation as a chronicler of happy family life: no father who provides his firstborn with a dangerous weapon can be said to be entirely at ease with the role enforced upon him by the child. The broken tambourine and the split pomegranate, both clear symbols of female defloration and fertility, instead display the artist's agony that his free bachelor's existence has been closed like a fan. Typical of the symbolic painting that he practiced before he met Karin, *Bizarrerie* expresses Carl's fear of having his creativity suffocated in the bosom of the family and his wife.

In *Little Suzanne,* however, Karin hurries to his assistance and with a firm hold on her daughter incites Carl to paint only the clear daylight that trolls cannot face. The skull of *Bizarrerie* is exchanged for a piece of cloth and a Japanese doll, and the dagger has disappeared from Suzanne's hand. The painting might be interpreted as the birth of the myth of the happy Larsson family, for thereafter no shadow was allowed to fall on it.

Still, it is not at all difficult to find evidence of Carl's depressive night side in his watercolors from Sundborn. Take for instance the sunny *Lazy Nook* (see p. 58). Of course it depicts a corner of the Larsson's living room as it actually was. But it can also be said to be filled with matrimonial symbols similar to those used by Jan van Eyck in his famous 1434 painting *The Marriage of Giovanni Arnolfini.* Above the sofa are three solid symbols of maternal strength: an engraving of Jean Baptiste Greuze's *Silence!*, depicting motherhood and the work of disciplining children; a cow by Paulus Potter, reminiscent of both the Greek fertility goddess Hera and of Karin herself, whom Carl described many times as "cow-eyed;" and a stuffed parrot in a wreath, a traditional Christian symbol for Eve in Paradise. Below these symbols is a picture of the Greek hero Herakles, looking as though he has in vain tried to lift his heavy club to defend himself against the female dominance above him.

In *Flowers on The Windowsill* (see p. 57) eleven-year-old Suzanne is seen tenderly watering her mother's flowers. Karin has apprently just left the scene, because the seat of her chair is still wrinkled by her weight and her knitting is left on the table. The innocent knitting can be interpreted as an ominous "black hole" and the cut piece of yarn next to it as Carl's thread of life. This thread recurs enlarged in the last Sundborn watercolor, *It's Getting Late, Goodnight!* (see p. 62), in which Karin seems again to be invisibly present. She is either sitting at the end of the table, reading the open book, or in front of the gaping scissors. If the latter is the case, she has just cut off a thick black thread and thrown it at Carl.

Carl Larsson
**It's Getting Late,
Goodnight!** *circa* 1909
Det kvällas, god-natt
Watercolor
Published as the
last plate in
Åt solsidan, 1910
[Whereabouts unknown]

The boldly abstract
textile set into the
back of the settee
was woven
by Karin Larsson.

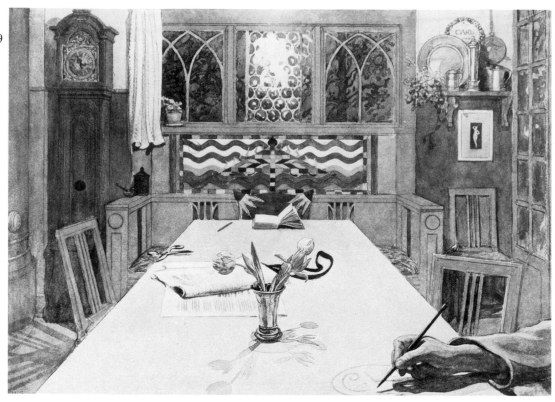

Carl Larsson
**Various Studies:
The Artist's Wife,
Children, and
Birds' Wings** 1890
Pen and wash
25.2 x 33.7 cm.
(9⅞ x 13 in.)
[Collection:
Nationalmuseum,
Stockholm, Sweden]
Cat. no. 60

*These quickly
sketched ink drawings
of Karin and two of
the children derive a
sense of mystery from
the pensive gazes of
the figures and the
intermingling of
studies of birds'
wings. Although the
wings have every
appearance of being
realist studies and not
inventions, their
juxtaposition with the
heads leaves the
image open to varying
interpretations.*

Various Studies: The Artist's Wife, Children, and Birds' Wings (facing page) shows Karin surrounded by children and ripped-off wings. Rather than expressing a sense of guilt for having pinioned his wife's artistic career, Carl here suggests that he felt pinioned by her. The same sort of Freudian castration anxiety also shines through in a cartoon, in which Carl voluntarily exposes his hair to Karin's enormous scissors.

So well concealed is the criticism of Karin in all these pictures that they need to be juxtaposed to bring it out. But in *Self-examination,* considered by Carl himself to be the most distinguished of his many self-portraits (Nordensvan, 1920), the artist's negative feelings toward his wife are obvious. She is glimpsed behind the window, her eyes hidden by the window frame, her mouth by a reflection in the glass. She cannot see her husband, nor tell him to refrain from making this picture, which she would probably have done if she had understood that the clumsy doll with a potato nose similar to her own was a symbolic portrait of herself. Carl seems to confess that he is well aware of his own tragedy: that he had hardly ever painted anything but the scenes that Karin arranged for him, empty and devoid of real life like the outstreched hand of the doll. It has been pointed out (Lindwall, 1953) that this unrestrained revelation of Carl's

Carl Larsson
Self-examination 1906
Självrannsaken
Oil on canvas
95.5 x 61.5 cm.
(37⅝ x 24¼ in.)
[Collection:
The Uffizi Gallery,
Florence, Italy]

Carl Larsson
Caricature vignette from
Ett hem, 1899

inability to live up to Sundborn's official happy grin shows the artist from the depth of self-disgust. And for anyone who studies his pictures attentively, this illustration of his depressive side does not come as a surprise.

The last years of Carl's life were darkened by the controversy over *Midwinter Sacrifice,* his painting for the entrance hall of the Swedish Nationalmuseum that was refused by the museum board. There are three versions of this painting; best known is the last one in oil. It shows a heathen king, deliberately sacrificing himself for his people. The king is standing naked in front of his executioner, who is prepared to stab him in the throat.

Carl confessed (Nordensvan, 1920) that he identified himself with the self-sacrificing king. Since the slit of the executioner's right-hand cuff is shaped like a heart, it seems probable that the artist felt himself being loved to death by his own people—the fatal knife is carried by a hand that loves. Subsconsciously he may even have identified his executioner with Karin.

Carl Larsson
Midwinter Sacrifice
1915
Midvinterblot
Detail of the central section of the final submitted version
Overall, approximately 7 x 14 metres (23 x 46 feet)
[On deposit at the Archive for Decorative Art, Lund, Sweden]

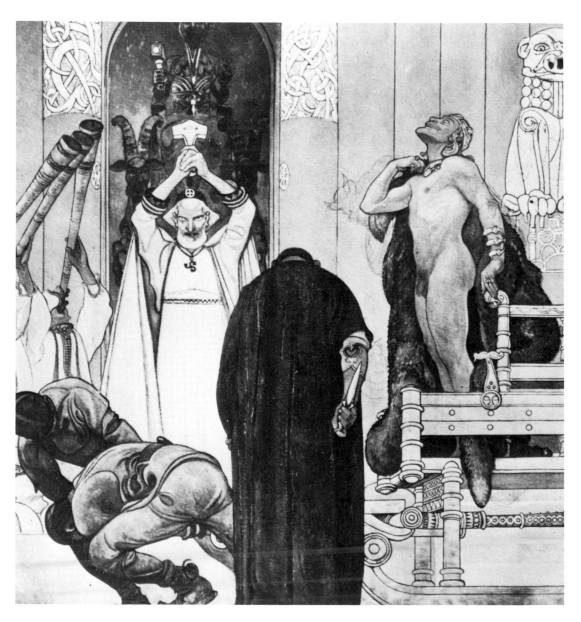

No one who studies Carl's many portraits of his beloved wife can deny that she represented both a positive and a negative force for him. But in what way did the real Karin actually deserve to be portrayed? That question is difficult to answer. All but one of the contemporary witnesses describe Karin as a thoroughly harmonious, good woman. The exception is the Swedish author August Strindberg, once an intimate friend of Carl's. When Strindberg turned against Carl in his *New Blue Book* of 1908, one of the things that pained Carl most was that Strindberg called Karin "a real devil." It is impossible to dismiss this simply as an outburst of Strindberg's well-known mysogyny, for it is also true that he was one of the most sharply observant figures in Sweden at that time. It may well be that Strindberg saw what Carl only subconsciously depicted in many of his pictures: the painter's submission to the strong creative power of his wife.

Whatever the truth, there is no reason for us to doubt either Karin's love for Carl, nor the testimonies of her happiness. Indeed she had reason to be happy, because

Carl Larsson
August Strindberg 1899
Charcoal and oil on canvas
56.0 x 39.0 cm. (22 x 15⅜ in.)
[Collection: Nationalmuseum, Stockholm, Sweden]
Cat. no. 25

Larsson and Strindberg had been friends and supporters of each other's work since the late 1870s. Larsson hailed Strindberg as "our Émile Zola" when the writer visited Grèz in 1883, and Strindberg wrote an article on Larsson's work in 1884 and later supported him for the Nationalmuseum fresco commission. To paint this portrait, Larsson travelled to Furusund, where Strindberg spent his summers. The centralized, frontal face with the name inscribed below it was a format he used for other portraits, as was the use of drawing for the finished work. Here the frontal pose is particularly suited to the intensity of the sitter's gaze. Although the portrait is inscribed "drawn by his old friend C.L.," in his last years Strindberg turned against Larsson. In a Blue Book of 1908, under the heading "Falsified Characters," the playwright wrote a bitter attack on the artist's life and personality, especially challenging his claim to be a good husband and father. Even though such personal attacks on his contemporaries, both direct and disguised in fiction, were not unusual for Strindberg, Larsson was deeply wounded.

together with her husband she created a utopian Swedish home that still serves as a dream and model of a more beautiful life for thousands of people.

A great love can easily be transformed into a burden for the man who has to live up to its requirements, and at least in his subconscious mind, Carl blamed Karin for the tragedy of his life: that he never attained the artistic heights of which he dreamt as a young artist. But should Karin really be blamed for her inability to help him succeed with paintings like *Midwinter Sacrifice,* which had a spirit so remote from her own understanding of the world? And was she equipped to comprehend the anguish her strength and social superiority created in him?

"Only male force can create a Parthenon frieze or the frescoes in Capella di Sixtina," Carl wrote in the 1870s in one of his many pleas against female artists. Apparently he saw himself as a Swedish Phidias and dreamt of becoming a great painter of the myths, rites, and festivals of his own people. *Now it's Christmas Again* may actually be his answer to the Greek master's frieze of the Panathenaic festival. That festival was the greatest annual event in Athens, just as Christmas is the greatest festival in Sweden, and in *Now it's Christmas Again* Carl tried to give the same sort of classic form to the Swedish celebration that Phidias had given to the Panathenaic procession. Of course he must have realized that he could never equal the greatest master of all. Perhaps, then, we should also interpret his depressive figure behind the Christmas tree as a resignation to his own shortcomings.

Cat. no. 86

BIBLIOGRAPHIC REFERENCES

H. and S. Alfons, *Carl Larsson skildrad av honom själv* (Stockholm, 1977).

I. Andersson, *Carl Larsson-gården—men Karin då?* (Institutionen för konstvetenskap, Uppsala universitet, 1980).

A. Frieberg, *Karin. En bok om Carl Larssons husfru* (Stockholm, 1967).

C. Larsson, *De mina* (Stockholm, 1895).

____, *Ett hem* (Stockholm, 1899).

____, *Larssons* (Stockholm, 1902).

____, *Svenska kvinnan genom seklen* (Stockholm, 1907).

____, *Åt solsidan* (Stockholm, 1910).

____, "Carl Larssons hem i Sundborn skildradt af honom själf," *Svenska Hem,* 4, pp. 157-165, Stockholm, 1916.

____, *Jag* (Stockholm, 1931).

B. Linde, "Carl Larsson," *Svenskt biografiskt lexikon 22,* pp. 288-234, Stockholm, 1978.

B. Lindwall, "Carl Larsson," *Carl Larsson,* Liljevalchs konsthall, katalog nr. 205, Stockholm, 1953.

G. Nordensvan, "Carl Larsson," *Sveriges Allmänna Konstförenings,* del. 1-2, publ. XXIX-XXX (Stockholm, 1920-21).

A. Strindberg, *En ny blå bok* (Stockholm, 1908).

E. Wägner, "Till fru Karin Larsson," *Idun* 25/5, p. 344, Stockholm, 1913.

E. von Zweigbergk, *Hemma hos Carl Larsson* (Stockholm, 1968).

Catalogue

Sarah Faunce

PAINTINGS

Note
Dimensions are in centimeters (inches in parentheses); height precedes width. Unless otherwise indicated, the medium is watercolor on paper. The collection is given in brackets.

1
Landscape Study at Barbizon 1878
Landskapstudie från Barbizon
oil on canvas
45.0 x 55.0 (17¾ x 21⅝)
[Nationalmuseum, Stockholm, Sweden]

Carl Larsson spent the summer of 1878 in Barbizon in the forest of Fontainebleau. For him, as for many other young European and American artists who had come to learn and test themselves in Paris, Barbizon with its rich tradition of mid-century landscape painting was a symbol and a mecca. During these early years in France, Larsson was still deeply involved with the late Romantic imagery, composed in the studio, which was to bring him no success at the Paris Salon. This little study is one of his earliest efforts at painting out of doors from the motif. In it his palette is still dark, and he is still working traditionally from a dark ground to light details. But the thin handling of the oil paint foreshadows the important change he was to make from oil to watercolor, as he gradually submitted to the pervading influence of plein-air painting.

2
In the Kitchen Garden 1883
I köksträdgården
93.0 x 61.0 (36⅝ x 24)
[Nationalmuseum, Stockholm, Sweden]
Illustrated, with commentary, on p. 26.

3
Autumn 1884
Höst
92.0 x 60.0 (36¼ x 23⅝)
[Nationalmuseum, Stockholm, Sweden]
Illustrated, with commentary, on pp. 10–11.

5
Interior with Karin Reading 1885
oil on panel
45.1 x 54.0 (17¾ x 21¼)
[Private collection, Minneapolis, Minnesota]

*Like many of their Nordic contemporaries, the Larssons were
moved by a desire to make of their native land a pictorial
subject, and in 1885 they left France and returned to Sweden
to live. In April and September of that year Larsson, together
with the Swedish painters Ernst Josephson and Karl
Nordström, was active in organizing the "Opponents"
exhibitions in Stockholm, the first major exhibitions of the
young generation of artists in opposition to the Royal Academy
of Fine Arts. The family lived in a small house in Åsögatan,
an outlying section of Stockholm. This painting of his wife
Karin at the desk in their sitting room shows the artist's
interest in painting a domestic interior some years before he
had developed the mature style with which he concentrated on
recording the interiors of the house in Sundborn. The white
painted chair with blue and white striped seatcover, the
temporarily abandoned knitting, and the flowering plants in
the window are all elements that will be found in the later
watercolors done in Sundborn.*

4
The Old Wall 1884
Gamla muren
90.0 x 59.0 (35⅜ x 23¼)
[Private collection, Sweden]

Here again, as in Autumn *(p. 10), Suzanne's nursemaid
Zerline is posed in the garden of the house in Grèz which Carl
and Karin Larsson rented after the birth of their first child.
Again in the manner of Bastien-Lepage, the sharply defined
figure is surrounded by a mist of foliage and stone with
occasional detail, like the white rose bush, picked out in sharp
focus. Despite the perspective of buildings in the background,
the effect is one of overall painterly flatness against which the
figure stands out. As in* Autumn, *the costume is distinctly
eighteenth-century in character, as is the black tricorne hat
which the young woman holds. This taste for the decorative
Rococo spirit was to continue throughout Larsson's career.*

6
Parisian Model *circa* 1886
Parisermodell
34.0 x 23.0 (13⅜ x 9)
[Prins Eugens Waldemarsudde, Stockholm, Sweden]

Though settled in Sweden, Larsson continued to make regular trips to the Continent. In 1886 he travelled with Ernst Josephson to Paris and to Italy. For Larsson, whose ambition was to become a mural painter, the trip was primarily made in order to study monumental painting. He also worked for a time in Paris, where this chiaroscuro study of a model was painted. Though Naturalist in style, the composition has a Japanese sense of assymmetry which is strengthened by the large lotus-like shape of the fan at the upper left.

7
By the River Loing at Grèz 1887
Vid Loing, Grèz
45.0 x 65.0 (17¾ x 25⅝)
[Private collection, Sweden]
Reproduced in color, with commentary, on p. 10.

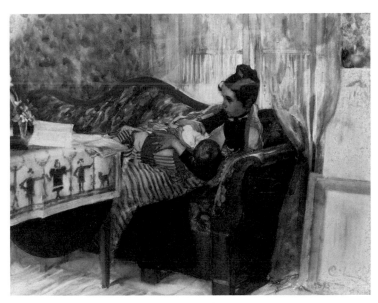

8
Karin and Brita 1893
Karin och Brita
45.0 x 58.0 (17¾ x 22⅞)
Published in *Larssons,* 1902
[Prins Eugens Waldemarsudde, Stockholm, Sweden]

Karin and Carl Larsson's fifth child, Brita, was born in 1893. That summer the family rented a cottage at Marstrand on the west coast of Sweden, where this study of Karin nursing the new baby was painted. Interestingly enough, although his wife and children were Larsson's preferred subjects from the 1890s onward, and there were to be two more children born by 1900, this most obvious maternal theme appears to be unique in his work. Possibly he felt the danger, always inherent in a frankly narrative/decorative style, of falling into sentimentality when dealing with the deeper ranges of experience. Here the feeling is tender but not excessive and is restrained by the natural pose, the mother's pensive expression, and the artist's interest in the surroundings, particularly the folk embroiderery cloth on the table. It is apparent that Larsson is no longer using watercolor with the highly polished precision of his Grèz years but is beginning to think more in terms of larger shapes and flat areas of local color.

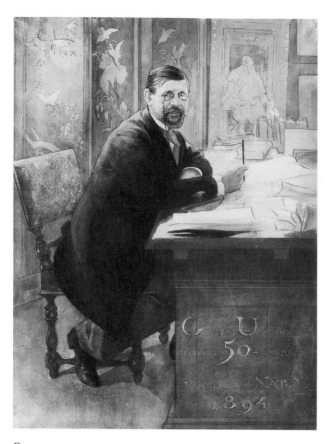

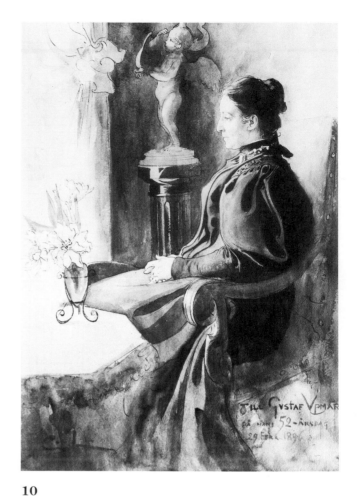

9
Portrait of Gustav Upmark (1844-1900) 1894
Porträtt av Gustav Upmark (1844-1900)
49.0 x 36.0 (19¼ x 14¼)
[National Portrait Gallery of Sweden, Gripsholm Castle]

Throughout his career Larsson made informal portraits, most often in watercolor and normally of friends, colleagues, and patrons. Gustav Upmark was the director of the National-museum in Stockholm who in the late 1880s initiated the competition for the fresco decoration of the great stairway hall in the museum. Larsson, after initially tying for first prize with another submission, ultimately won the commission with his proposals for six scenes from the history of seventeenth- and eighteenth-century Swedish art (see pp. 30 and 31). This portrait is inscribed to "Gustav Upmark on his fiftieth birthday from his friends at the Nationalmuseum." The director is shown seated at his desk in front of a screen decorated in the fashionable oriental style. The royal portrait on the wall accentuates his aura of authority. Larsson's second book of pictures, Larssons, published in 1902, was dedicated to Upmark.

10
Portrait of Eva Upmark 1896
Porträtt av Eva Upmark
46.0 x 33.0 (18⅛ x 13)
[National Portrait Gallery of Sweden, Gripsholm Castle]

Among Larsson's most successful portraits are those of his patrons' wives: a painting of Gothilda Fürstenburg, wife of the man who helped him begin his career, is in the Gothenburg Art Gallery, and a portrait of Signe Thiel, wife of the Stockholm collector who was an active patron of Larrson after 1900, is in the Thiel Gallery in Stockholm. This study of Eva Upmark is inscribed to her husband on his fifty-second birthday. Though painted two years later than her husband's portrait, it is deliberately done in the same manner, with the central figure surrounded by very lightly sketched-in attributes, in this case of a private and domestic nature.

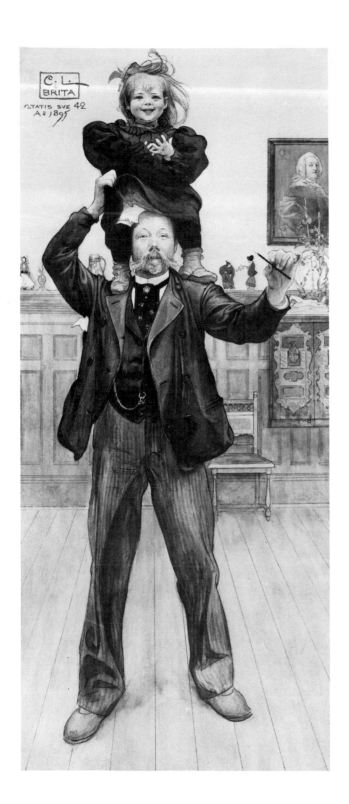

11
Brita and I 1895
Brita och jag
64.0 x 28.0 (25¼ x 11)
Published in *Larssons*, 1902
[Göteborgs Konstmuseum, Sweden]

*In the early 1890s Larsson was deeply involved with major
mural commissions: the large open stairwell of the Girls' High
School in Gothenburg, which he decorated on the theme of
Swedish women from Viking to modern times (completed
1891); and the entry walls of the Nationalmuseum in
Stockholm (completed 1896, see pp. 30 and 31). At the same
time, he turned increasingly to watercolors of domestic subjects,
to what he called, with his characteristic blend of bonhomie
and theatricality, "the happy and charming scenes which are
played all the time under my eyes." Several watercolors dated
1894 (for example,* Lisbeth *and* Ulf and Pontus, *both in the
Gothenburg Art Gallery) show him still in transition from his
earlier Naturalism to the flat linear clarity of his mature style.
In* Brita and I, *dated 1895, one can see all the elements of his
mature style: the firm line, the strong silhouette, the horizontal
banding of the field, and the decorative use of decor. Not
surprisingly, Larsson made quite a few self-portraits
throughout his career (see cat. nos. 23 and 48). In the
introductory text to* Larssons, *the picture book in which this
watercolor was first published, Larsson makes a dramatic tale
out of discovering the motif by chance in front of a mirror and
then proceeding to keep the two-year-old posing for a whole
week, protesting all the time. This evident impossibility
provides an example of the way in which Larsson enlivened his
text to suit the pictures he made.*

12
In the Corner *circa* 1895
Skamvrån
32.0 x 43.0 (12⅝ x 17)
Published in *Ett hem*, 1899
[Nationalmuseum, Stockholm, Sweden]

Reproduced in color, with commentary, on p. 20.

13
Lazy Nook *circa* 1895
Lathörnet
32.0 x 43.0 (12⅝ x 17)
Published in *Ett hem*, 1899
[Nationalmuseum, Stockholm, Sweden]

Reproduced in color, with commentary, on p. 58.

14
Flowers on the Windowsill *circa* 1895
Blomsterfönstret
32.0 x 43.0 (12⅝ x 17)
Published in *Ett hem*, 1899
[Nationalmuseum, Stockholm, Sweden]

Reproduced in color, with commentary, on p. 57.

15
Old Anna *circa* 1895
Gamla Anna
32.0 x 43.0 (12⅝ x 17)
[Nationalmuseum, Stockholm, Sweden]

Reproduced in color, with commentary, on p. 14.

16
The Studio *circa* 1895
Ateljén
32.0 x 43.0 (12⅝ x 17)
Published in *Ett hem*, 1899
[Nationalmuseum, Stockholm, Sweden]

Reproduced in color on back cover.

The studio along the west front of the Larssons' Sundborn home was the first addition made to the cottage. Completed in 1890, the year after the house became theirs, it was designed and furnished with the practical, sophisticated eclecticism and private whimsy characteristic of the Larssons' style. The settee which strikes such a brilliant note of Chinese red was built with a tall hollow post that acted as a paint cabinet and was topped by a three-dimensional example of one of Larsson's many self-caricatures. Above the settee is a lancet window in the English style which opens not to the outside but to the dining room and is painted with medieval motifs to resemble the stained glass decorations that were a feature of the Arts and Crafts style. The door, Larsson's favorite decorative field, contains an image of Karin which establishes her presence as a permanent witness of what takes place in her husband's workroom. The old woman—presumably the servant Anna—is shown seated as if between poses for the figure of the sixteenth-century woman which is sketched in on the easel. This painting makes clear that, far from happening upon his motifs by accident, Larsson was quite deliberate in his compositions and not above setting up an artificial situation that pleased him as a painting. Although this work was painted no earlier than 1895, the drawing of the costumed figure on the easel was done for an 1891 commission— the stairwell program "Swedish Women through the Centuries" *made for the Gothenburg Girls' High School. Since the Larssons did not begin to spend their summers in Sundborn until 1890, when their time was taken up by construction, it is unlikely that any of the studies for the project were made there, let alone in the completed studio, and certainly not in 1895.*

17
Papa's Room *circa* 1895
Pappas rum
32.0 x 43.0 (12⅝ x 17)
Published in *Ett hem*, 1899
[Nationalmuseum, Stockholm, Sweden]

Reproduced in color, with commentary, on p. 50.

18
Brita's Nap *circa* 1895
Britas tupplur
32.0 x 43.0 (12⅝ x 17)
Published in *Ett hem*, 1899
[Nationalmuseum, Stockholm, Sweden]

Illustrated, with commentary, on p. 16.

19
The Verandah *circa* 1895
Verandan
32.0 x 43.0 (12⅝ x 17)
Published in *Ett hem*, 1899
[Nationalmuseum, Stockholm, Sweden]

Illustrated, with commentary, on p. 51.

20
Sunday *circa* 1898
Söndag
68.0 x 104.0 (26¾ x 41)
Published in *Larssons*, 1902
[Nationalmuseum, Stockholm, Sweden]

Reproduced in color, with commentary, on p. 56.

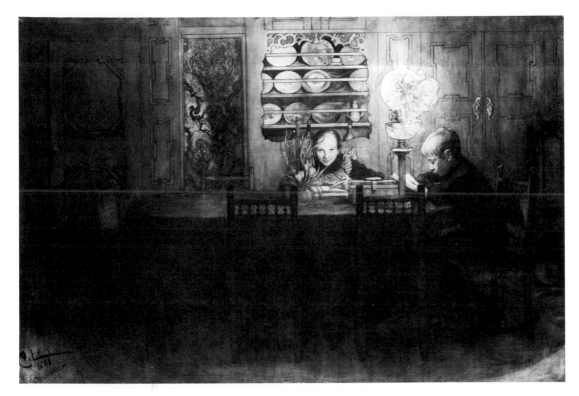

21
Homework 1898
Läxläsning
68.0 x 102.0 (26¾ x 40⅛)
Published in *Larssons,* 1902
[Göteborgs Konstmuseum, Sweden]

*Of Larsson's many interiors, few are nighttime scenes; bright
daylight was his more usual setting. This picture shows
Suzanne and Ulf studying at the table in the family's
Stockholm house, where they lived during the winter before
moving to Sundborn in 1901. The light of the lamp with its
curious blown-glass floral decoration falls upon elegant
seventeenth-century Frisian panelling that Larsson later
installed in the home at Sundborn. The almost sinister vitality
of the lamp's decoration and the Baroque panel set in the wall
is matched by the girl's fixed stare. There is an interesting
affinity of atmosphere between this painting and Maurice
Boutet de Monvel's* The Old Nurse, *an image which Larsson
would have seen in* The Studio *magazine of 1895.*

22
Required Reading *circa* 1898
Ferieläsning
46.0 x 64.0 (18⅛ x 25¼)
Published in *Larssons,* 1902
[The Art Museum of the Ateneum, Helsinki, Finland]

Illustrated, with commentary, on p. 22.

23
Before the Mirror 1898
Framför spegeln
65.2 x 41.4 (25⅝ x 16¼)
[The Zorn Museum, Mora, Sweden]

The year following the popular success of the exhibition of the
Ett hem *watercolors, Larsson's friend and fellow Swedish
painter Anders Zorn commissioned a piece from him for the
going price of 500 kroner. Larsson chose to make it a study of
the female nude, Zorn's favorite subject. The smoothly
sensuous yet somehow innocent quality of the figure is typical
of Larsson's treatment of the nude, which he worked from
regularly, and is very different from Zorn's bravura fleshiness.
By using the mirror (in what appears to be the same room of
his house in Stockholm where he painted the mirror portrait
Brita and I—cat. no. 11) he was able to provide a self-portrait
as well. The mirror itself, with its grand Empire frame, is as
it were a third motif of the painting. Despite its size, this
mirror was later installed in a small dressing room in the
house at Sundborn.*

24
Portrait of the Architect Jac Ahrenberg 1898
Arkitekt Jac Ahrenbergs porträtt
53.0 x 36.0 (20⅞ x 14⅛)
[The Art Museum of the Ateneum, Helsinki, Finland]

*Jacob Ahrenberg was a Finnish architect and writer who
shared with Larsson National Romanticism's new respect for
indigenous building traditions. His church at Kajaani, built in
1896, uses forms derived from both earlier wooden churches
and the nineteenth-century style of profuse decorative wooden
ornament known as "carpenter's Gothic." He poses casually as
a friend visiting Larsson's studio in Stockholm. One of the
several studio works that surround him is a drawing for* Brita
and I *(cat. no. 11).*

25
August Strindberg 1899
charcoal and oil on canvas
56.0 x 39.0 (22 x 15⅜)
[Nationalmuseum, Stockholm, Sweden]
Illustrated, with commentary, on p. 65.

26
Convalescence 1899
Konvalescens
52.0 x 66.0 (20½ x 26)
Published in *Larssons,* 1902
[Nationalmuseum, Stockholm, Sweden]

In painting this theme of the sickroom, Larsson was not only recording a moment in family history—Karin's recuperation from a serious bout with pneumonia—but also taking up a theme found frequently in late nineteenth-century Nordic painting. Despite the depth of his fear for her life and his gratitude for her recovery—recorded with genuine, if dramatically phrased feeling in the text of Larssons—*it was not in his nature to make of the theme anything nearly as stark or searing as the treatments of the motif painted by the Norwegian artists Christian Krohg and Edvard Munch. Although his wife's thin, pale face is tenderly observed, the image is essentially that of a charming and simple interior made poignant by the sick woman's fragility. It is one of the artist's most subtle color compositions, with tones of gold and rose played against the various whites of the bedclothes, the walls, and the painted furniture. The strong area of black behind the bed, perhaps symbolizing the death which had threatened, is a brilliant foil for the white bed and table and the vase of pink tulips. It is an example of what Larsson can do best: compose with a few subtly related colors and simple, clearly defined shapes parallel to the picture plane.*

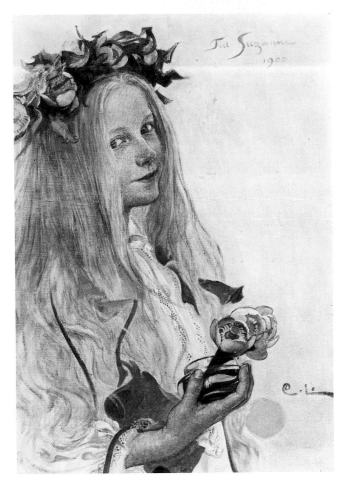

27
Suzanne: A Study 1900
oil on canvas
70.0 x 50.0 (27½ x 19⅝)
[Private collection, Sweden]

This oil study is a detail from a watercolor called Gratulation *(published in* Larssons*) that was made for Karin's name day in 1899. The watercolor shows Suzanne with another girl her age and one of her brothers greeting Karin with breakfast in bed. The children are draped in long white dresses with flower garlands on their heads and strands of water lily pods dangling from their shoulders. While this oil painting could be a study for the watercolor that was inscribed later as a gift to his daughter, it is more likely to be a restatement of a detail of the watercolor done with little change except for the addition of some lacy detail in the dress.*

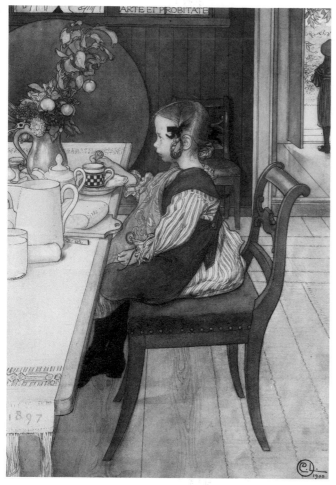

28
Lie-abed's Sad Breakfast 1900
Sjusofverkans dystra frukost
50.0 x 35.5 (19¾ x 14)
Published in *Larssons*, 1902
[The Art Institute of Chicago, Illinois]

The Larssons' youngest daughter Kersti is shown seated alone in the dining room with a familiar childhood expression of half-reproachful dejection on her face. Though Larsson liked to make up stories about his pictures as if they were illustrations of an ongoing family saga, in fact the pictures came first and the stories later. This is one of the relatively few Sundborn watercolors in which the traditional mood of direct narrative common to Victorian genre paintings of children prevails. While the child's figure is seen head-on, the table and floor are composed in an uptilted perspective reminiscent of the Japanese prints that Larsson admired and collected. The tablecloth, dated 1897, is one of Karin's early embroideries.

29
Suzanne and Another 1901
Suzanne och en ann'
94.0 x 62.5 (37 x 24⅝)
[Private collection, Sweden]
Reproduced in color on front cover.

In 1901, when the Larsson family went to live year-round in the house at Sundborn, a new phase of building and remodelling began. As the eldest girl, Suzanne, aged eighteen, acquired a little room of her own. Here she is shown helping to paint the decorative frieze of day lilies and sunflowers designed by her father around the top of the clean white wall. Two of the Sundborn craftsmen who helped the Larssons to build their house are at work on the outside. The effect of the two subtly different shades of blue—more violet in the dress, more green in the chair—is striking against the light-washed walls.

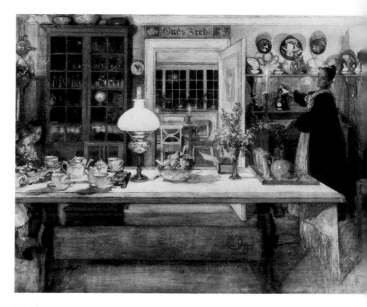

30
Before the Little Card Party 1901
Till en liten vira
oil on canvas
68.0 x 92.0 (26¾ x 36¼)
Published in *Larssons*, 1902
[Nationalmuseum, Stockholm, Sweden]

An example of Larsson's infrequent use of the oil medium in his Sundborn paintings, this canvas shows the dining room being prepared for guests who are coming to play a game of cards called "vira" in the sitting room seen through the door at the center. The side of the room depicted is the wall opposite that shown in Old Anna *(p. 14). Here the overdoor motto is a much simpler one: "God's Peace" written in Dalarnan peasant style. Larsson revels in sumptuous detail, celebrating not only the room with its china-laden shelves and closets but also the table laid with a blue and white coffee set, dishes of cakes, a bowl of fruit, a box of cigars, and a tray of liqueurs and glasses.*

32
Outdoors Blows the Summer Wind 1904
Ute blåser sommarvind
30.0 x 101.0 (11⅞ x 39¾)
[The Art Museum of the Ateneum, Helsinki, Finland]

*In 1903 Larsson completed a large thirty-six foot wide
painting to be installed in the Gothenburg Latin School. In it
he used figures drawn from his life in the country to compose a
moral allegory. This gouache dated 1904 is a repetition of the
theme, possibly intended for publication, but not completed in
detail. Children and farm women proceed towards the left,
bringing flowers and tools to decorate the school for the Mid-
summer festival. The youth, strength, and abundance of these
figures symbolize the renewal of life celebrated at this high
point of the Nordic year. Moving in the opposite direction are
the figures of a woman dressed for a funeral, a mounted
soldier, and a bent old man—images of the hardship, struggle,
and death which will confront youth during the course of life.
The emphatically horizontal, processional character of the
composition is one which Larsson began at this time to favor
for his larger paintings and mural decorations.*

31
Waking Up Prins Eugen at Sundborn 1902
Morgonuppvaktning för Prins Eugen
på Carl Larsson gården
63.0 x 45.0 (24¾ x 17¾)
[Prins Eugens Waldemarsudde, Stockholm, Sweden]

*Prins Eugen (1865-1947) was a son of the Swedish royal
family who devoted his life to painting both as a serious
painter of Symbolist landscapes and as an outstanding collector
of the art of his contemporaries. Larsson had known him since
the late 1880s, when they met in Paris while Eugen was
studying with Léon Bonnat and Pierre Puvis de Chavannes.
The prince spent the night at Sundborn in March of 1902,
staying in the so-called Old Room in which an antique
cupboard bed had been installed along with the Frisian
panelling formerly in the house in Stockholm (see cat. no. 21).
A poem in praise of Eugen based on a Swedish hymn is
inscribed beneath the image. Whether or not the prince was
actually wakened by two of the girls holding long tapers, it is
doubtful that even Larsson, with his fondness for theatrical
celebrations, would have included the choir and string players
seen through the doorway. More probably the picture was made
as a kind of flattering conceit for a gift to the notable visitor. It
remains in the house that Prins Eugen built for himself and
his collection, which he later donated to the nation.*

33
On the Model's Table 1906
På modellbordet
57.0 x 77.5 (22½ x 30½)
[Göteborgs Konstmuseum, Sweden]

*The so-called lay figure, a flexible jointed dummy that could be
used to supplement studies from the nude, was a common
device in the studios of artists who, like Larsson, continued to
use the idealized nude figure as a theme for mural decoration.
During 1905-06 Larsson was working on decorations for the
Dramatic Theatre in Stockholm and so making use both of the
live and the artificial model. (Two studies for this project are
seen on the background wall.) Far from differentiating the two
kinds of models, here Larsson has given the lay figures, in
particular the lower one, incongruous attributes of life: a male
sex not normally part of a lay figure's equipment, and a
gravity-defying foot. This, together with the frank treatment of
the female nude and the drawing of the embrace on the wall,
makes of the picture a fairly direct if discreet sexual statement.*

34
Now It's Christmas Again 1907
Nu är det jul igen
oil on canvas
triptych, overall 178.5 x 455.0 (70⅛ x 179)
[The Helsingborg Museum, Sweden]

Illustrated, with commentary, on pp. 54-55.

35
Now It's Christmas Again 1907
Nu är det jul igen
56.0 x 146.0 (22 x 57½)
[Mr. and Mrs. Arthur G. Altschul, New York]

Reproduced in color, with commentary, on p. 54.

36
The Bridesmaid 1908
Brutärnen
52.0 x 75.0 (20½ x 29½)
Published in *Åt solsidan*, 1910
[The Art Museum of the Ateneum, Helsinki, Finland]

Larsson was fifty-seven when he published Åt solsidan, *like
his earlier books a series of watercolors of domestic subjects
with a descriptive anecdotal text inset with black-and-white
vignettes. Though age had brought with it such pains of loss
and alienation as his eldest son's death and August
Strindberg's bitter attack (see p. 65), he struggled to maintain
and project an attitude of cheerfulness. Typically he wrote,
"This is life. For better or for worse. We have to live it, and
live it as best we can. All this you know as well as I do, but we
must, if we are not to despair, constantly shout encouraging
calls to each other, and say, 'What wonderful weather today!'"*

*This watercolor shows Karin working on the hem of
Lisbeth's bridesmaid's dress in a room in the house at Falun,
the provincial capital not far from Sundborn where the
children lived during the week while going to school. Although
the furniture here is more formal and conventional than that
at Sundborn, and the setting is treated with less detail than is
found in the* Ett hem *series, Larsson continues to compose
with a clear sense of color and pattern. Against the muted
greens, blues, and mulberries of the setting, the large shapes of
the contrasting figures are assymmetrically placed. Karin's
dress of blue and white floral print is treated like the robes in
Japanese prints, as a large silhouette in which bodily structure
is indicated only through shifts in the pattern of the cloth. The
sense of composition in terms of color relationships is
heightened by the brilliant note of the lemon-yellow frame
around a gray field in the exact center of the picture.*

37
After the Ball in the Studio 1908
Efter balen i ateliern
52.0 x 74.5 (20½ x 29⅜)
Published in *Åt solsidan*, 1910
[The Malmö Museum, Sweden]

Suzanne, who at the time of this painting was twenty-five
years old and working as a nurse in Stockholm, is shown
resting in the candlelit studio after a late party. A full-scale
study of a wall painting made for the Norra Latin School in
Stockhom in 1901 is installed on the wall behind her. The
picture is composed in tones of apricot, rose, and pale green,
with much attention given to the colors of reflected light,
particularly in the folds of the patterned dress.

38
The End of Summer (Karin by the Shore) 1908
Efter sommer (Karin vid strand)
52.6 x 74.5 (20¾ x 29⅜)
Published in *Åt solsidan*, 1910
[The Malmö Museum, Sweden]

Reproduced in color, with commentary, on p. 6.

39
Summer Morning 1908
Sommarmorgon
50.2 x 71.0 (19¾ x 28)
Published in *Åt solsidan*, 1910
[Mr. and Mrs. Arthur G. Altschul, New York]

Reproduced in color, with commentary, on p. 24.

40
Home's Good Angel 1909
Hemmets goda ängel
51.0 x 73.0 (20⅛ x 28¾)
Published in *Åt solsidan*, 1910
[Private collection, Sweden]

Reproduced in color, with commentary, on p. 48.

41
Anna Arnbom 1909
51.7 x 73.7 (20⅜ x 29)
Published in *Åt solsidan*, 1910
[Mr. and Mrs. Arthur G. Altschul, New York]

Reproduced in color, with commentary, on p. 37.

42
The Cottage in the Snow 1909
Stugan i snö
watercolor on paper mounted on canvas
63.0 x 96.0 (24¾ x 37¾)
Published in *Åt solsidan*, 1910
[Turku Art Museum, Finland]

Illustrated, with commentary, on p. 42.

43
Karin and Brita with Cactus
Karin och Brita med Kaktus
76.0 x 112.0 (29⅞ x 44⅛)
[Private collection, Sweden]

Reproduced in color, with commentary, on p. 52.

44
Grandfather 1909
Farfar
oil on canvas
75.0 x 50.0 (29½ x 21⅝)
[Sundborn, Carl Larsson-Gården, Sweden]

Despite its title and the presence in the middle distance of the
gray and bent-over figure of Larsson's father, this is essentially
a study of summer flowers in the Sundborn garden. From the
Larssons' first summer in the house in 1889, Karin had
begun to make a garden based directly on the English cottage
garden, with its informal mixture of colors and types, its use of
such common field flowers as daisies, sunflowers, and day
lilies, and its atmosphere of abundance, with plenty of
blossoms for cutting. These elements of the cottage garden were
beginning to be used during this period by the most
sophisticated English garden designers. The floral designs that
Larsson painted on the walls of the house were most often
based on the natural growth patterns of the garden (see cover
and p. 16), and bunches of cut flowers are frequently seen in
his pictures.

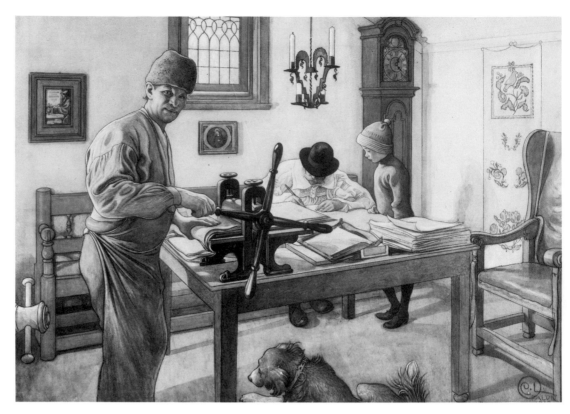

46
In the Printing Studio 1910
Mitt etslokus
67.0 x 89.0 (26⅜ x 35)
Published in *Åt solsidan,* 1910
[The Helsingborg Museum, Sweden]

In his house at Falun Larsson set up a printing studio where he could make etchings. Although he had produced etchings since the late 1870s, the majority of his work in this medium dates from the mid-1890s to 1912. His subjects were mostly intimate: the household (see cat. no. 76), friends' portraits, and nude studies. Here he is shown working on a print, while his youngest son Esbjörn looks on and a local man named Hans Fröjd assists him at the handpress. The prominence of Fröjd and his distinctive face make of this picture a kind of artisanal portrait akin to the series of portraits he made for the town of Sundborn (see cat. nos. 52 and 53). Such a portrait of a craftsman at work in a typical Larsson interior is in fact more successful than his official portraits, although the townspeople, as well as the subjects, probably thought the formal oil paintings more suitable.

45
Lisbeth with Peonies *circa* 1909
Lisbeth med pioner
96.0 x 63.0 (37⅞ x 20¾)
[Private collection, Sweden]

Reproduced in color on p. 33.

This charming image of Lisbeth cutting garden flowers for the house (see cat. no. 44) is reminiscent of the single figures of prettily dressed young women in garden settings seen in Larsson's Grèz watercolors of the early 1880s (see p. 10). Athough Naturalistic technique has given way to a mature linear style, the sensibility remains and is reinforced by the tenderness that the artist felt for his young daughter.

47
Suzanne on the Front Step 1910
Suzanne på förstubron
63.0 x 98.0 (20¾ x 38⅝)
[Private collection, Sweden]

Reproduced in color as frontispiece

This close-up view of the Sundborn house's entry porch, when compared with The Verandah *of circa 1895 (see p. 51), shows the alterations that the Larssons made in the interim: the addition of a wide row of windows at the left, and a small flower bed by the steps. Larsson's wiry drawing line is at its liveliest in this depiction of healthy growing plants.*

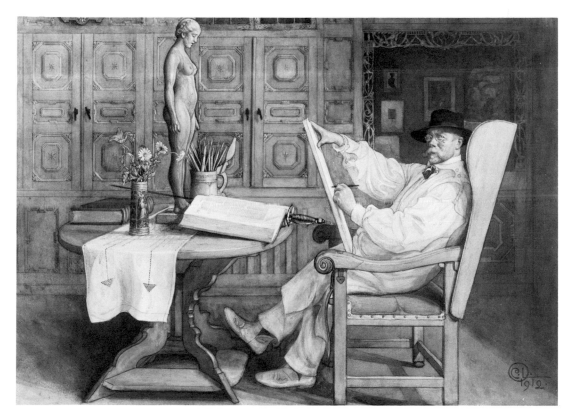

48
Self Portrait 1912
Självporträtt
54.3 x 75.0 (21⅜ x 29½)
[The Malmö Museum, Sweden]

*The artist is seated at a table in the Old Room, actually a part
of the new wing added in 1901, but so-called because it was
fitted with seventeenth-century Frisian panelling from the
family's Stockholm house, a cupboard bed for guests (see cat.
no. 31), and other antique decorative objects that Larsson had
collected. Larsson presents himself here as every inch the artist:
swathed in a smock, pen and brushes at the ready, with a
stand-in model in the form of a favorite bronze sculpture of an
academic nude. The sword, curiously extended through the
book like some outlandish bookmark, is a relic of Larsson's
days as a painter of Romantic subjects, and some nostalgia for
its symbolism must have led him to keep it as a studio prop (see
p. 60). There is perhaps room for a Freudian interpretation of
its placement between the artist and the sculptured nude, whose
gaze is directed downward at it.*

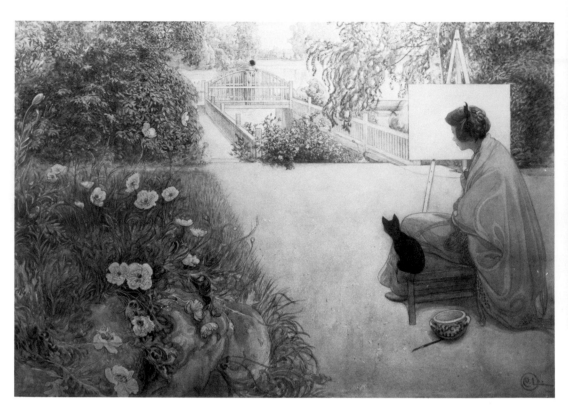

49
The Bridge *circa* 1912
Brð
53.0 x 75.0 (20⅞ x 29½)
[Private collection, Finland]

The view is from the front garden of the house, looking toward the Sundborn River, at the edge of which had been built a little bridge across an enfenced boat inlet. On the bridge is one of the young nude models that Larsson sometimes used. Although such a sight would have been familiar to the Larsson children, the well-wrapped daughter appears to be gazing with a curiosity that is emphasized by the presence of an unmistakeably interested cat.

51
Interior with Cactus 1914
Interiör med Kaktus
70.0 x 92.0 (27½ x 36¼)
[The Helsingborg Museum, Sweden]
Reproduced in color, with commentary, on p. 36.

50
Dalarnan Girl by a Wooden Storehouse *circa* 1912
Lisskulla vid härbre
96.0 x 62.0 (37⅞ x 24⅜)
[Ragnar and Birgit Åhléns Foundation, Falun, Sweden]

*When his own children grew older, Larsson occasionally
turned to his neighbors for the young subjects which clearly
delighted him. Here he accentuates the smallness of the child
by nearly filling the field with the rough wooden structure
before which she stands. Although there was one of these
traditional farm buildings on the Larsson property that had
been made over into extra sleeping space for servants and
children, this one is in its original, now rather well-worn
condition. The old iron fittings and the grain of the weather-
beaten wood are lovingly observed, while the fresh pattern of
the child's dress shows us why Karin, with her feeling for
textile design, chose to make her own and her daughter's
clothes from local cloth.*

52
The Cabinetmaker 1915
Snickaren
oil on canvas
123.0 x 98.0 (48⅜ x 38⅝)
[Falun Municipality, Sweden]

*Beginning in 1905, when he painted the local minister C.F.
Pettersson (for whose church he had provided the decorative
scheme), Larsson did many portraits of his Sundborn friends
and associates—not only the town fathers but also the workmen
who had helped him at his house. Chief among the latter was
Hans Arnbom, the carpenter who built all the additions to the
house and carried out the Larssons' many woodworking
designs. In his portrait, which is inscribed to "my friend and
masterbuilder H. Arnbom," he is seated in Larsson's studio in
front of finely-worked wood panelling and a collection of
ornamental knives. The two comic dolls, which have Larsson's
style of cartoon caricature, may have been made by Arnbom to
Larsson's designs. The one on the left is used in several other
pictures (see illustration on p. 63).*

54
Karin 1883
ink on paper
15.0 x 15.0 (5⅞ x 5⅞)
[Private collection, Sweden]

55
Little Suzanne 1885
ink on paper
34.6 x 23.5 (13⅝ x 9¼)
[Nationalmuseum, Stockholm, Sweden]
Illustrated, with commentary, on p. 60.

53
The Smithy 1915
Smeden
oil on canvas
123.0 x 98.0 (48⅜ x 38⅝)
[Falun Municipality, Sweden]

Like The Cabinetmaker *and the others in this series of local portraits,* The Smithy *was made as a gift to the village of Sundborn, which had enabled Larsson to realize his dream of making a true "artist's house" in the heart of Sweden's most essentially Swedish province. The smithy was of course not a simple shoer of horses, but the town's metalworker. He is seated in front of a fireplace which recalls his forge and above which is an ornamental brass sconce. The whole series of portraits hangs today in the Sundborn village hall.*

56
Study of Trees 1885
chalk, pencil, and wash
55.0 x 30.5 (21⅝ x 12)
[Nationalmuseum, Stockholm, Sweden]

This watercolor study is inscribed "Åsögatan" after the partially rural area of Stockholm where the Larssons lived when they left France to settle in their native country.

57
The Open-Air Painter *circa 1886*
black chalk, heightened with white
30.5 x 50.0 (12 x 19¾)
[Nationalmuseum, Stockholm, Sweden]

Larsson and his Nordic contemporaries had learned the techniques of plein-air *painting at its source in France, where for most of the year it is possible to work* sur le motif. *Some ironic, or at least humorous comment is surely implied by the depiction of the* plein-air *painter at his easel in the midst of a snowy Swedish winter. The local folk who are observing him are probably less curious about his picture than as to why he is there at all. A large 1886 painting of this subject—Larsson's neighborhood in Åsögatan—is in the Nationalmuseum in Stockholm.*

58
Ceramic 1887
ink on paper
45.0 x 29.0 (17¾ x 11⅜)
[Nationalmuseum, Stockholm, Sweden]

Illustrated top right.

This and the following drawing are among the many that Larsson produced in the 1880s and early 1890s when he still depended on income from book illustration and free-lance work for magazines and newspapers. The craft of ceramics is personified, in a way typical of the period, by the figure of a young woman painting decorations on china plates. Unlike the more common stylized versions of this image, Larsson's figure is an ordinary woman in a specific setting, complete with a dapper admirer.

59
Autumn n.d.
Höst
ink on paper
28.3 x 19.5 (11⅛ x 7⅝)
[Nationalmuseum, Stockholm, Sweden]

Illustrated right.

Autumn is here personified by the figure of a young man dressed in eighteenth-century style, holding a scythe made for serious reaping, but carrying a decorative garland of grains and autumnal fruits.

60
**Various Studies: The Artists's Wife,
Children, and Bird's Wings** 1890
pen and wash on paper
25.2 x 33.7 (9⅞ x 13)
[Nationalmuseum, Stockholm, Sweden]

Illustrated, with commentary, on p. 62.

61
Cocotte and the Artist (caricature) *circa* 1890
ink and wash on paper
35.5 x 22.0 (14 x 8⅝)
[Nationalmuseum, Stockholm, Sweden]

*Larsson was fond of making rapid pen-and-ink caricatures of
himself and others. Here he parodies himself as decidedly* not
*the family man, paired in an unmistakably sexual way with a
fancifully accoutred fancy woman whose attributes are
contradicted by the jaded expression on her face.*

62
The Poor Box at Sundborn *circa* 1890
watercolor and pencil on paper
70.0 x 41.5 (27½ x 16⅜)
[Nationalmuseum, Stockholm, Sweden]

Like the 1885 Study of Trees *(cat. no. 56), this watercolor
study shows Larsson continuing to work in the style of
plein-air* Naturalism *he had developed in Grèz, while focusing
more on specific motifs than on complete compositions. The
poor box, where passersby could leave alms, obviously interested
him, perhaps because of the contrast between his happy adult
life and his deprived childhood. He made a painting of the
subject, which can be seen on the floor in the studio vignette in*
Ett hem *(see cat. no. 82) and in an independent text vignette in
the same book.*

63
**Scenes from Swedish Art History:
Ehrenstrahl and Carl XI;
Nicolas Tessin the Younger with Hårleman;
Taraval's Academy. Studies for the Frescoes
in the Nationalmuseum, Stockholm** 1890-91
oil on canvas
110.5 x 134.0 (43½ x 52¾)
[Nationalmuseum, Stockholm, Sweden]

Illustrated, with commentary, on p. 30.

64
Scenes from Swedish Art History:
Lovisa Ulrika and Tessin;
Gustavus III; Sergel in his Studio.
Studies for the Frescoes in the
Nationalmuseum, Stockholm 1890-91
oil on canvas
110.5 x 134.0 (43½ x 52¾)
[Nationalmuseum, Stockholm, Sweden]
Illustrated, with commentary, on p. 30-31.

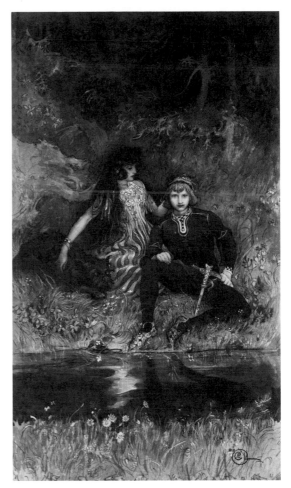

65
The Strangers from the Land of Egypt 1894
Illustration from *Singoalla* by Viktor Rydberg
India ink and white body-color on paper
45.2 x 27.0 (17¾ x 10⅝)
[Göteborgs Konstmuseum, Sweden]

Larsson illustrated Singoalla, *an early seventeenth-century folk tale retold by a modern author, in a spirit of National Romanticism that matched the book's text. It was his last work of illustration for a book not his own, and it represents a decisive break from his earlier late-Romantic and Naturalist styles. While still dealing with a world of fantasy, these drawings show Larsson in command of his mature drawing style of flowing line and flat, decorative composition. Depicted here is a wild gypsy dance performed in front of a medieval wood and stone setting.*

66
Erland and Singoalla at the Brook 1894
Illustration for *Singoalla* by Viktor Rydberg
India ink and white body-color on paper
45.0 x 27.0 (17¾ x 10⅝)
[Göteborgs Konstmuseum, Sweden]

Early in 1894 Larsson made a charcoal drawing (now in the Thiel Gallery in Stockholm) of Karin holding a lighted candle in a dark room. The nocturnal tonality of that work, which recalls drawings made by the Belgian Xavier Mellery in the early 1890s, reappeared later the same year in many of his Singoalla *illustrations. Here the clear-cut horizontal bands dividing the field, and the scribbly yet precise drawing line, are the same that can be seen in the* Ett hem *watercolors of the years immediately following the publication of* Singoalla.

67
Studies of Gustaf Björk 1895
pencil on paper
27.2 x 22.0 (10¾ x 8⅝ in.)
[Göteborgs Konstmuseum, Sweden]

The inscription on this drawing states that Gustaf Björk was the model for the "black sheep" ("Sorgebarn") in Singoalla. *Since the illustrations were completed in 1894, it is possible that the sheet was inscribed and signed later and misdated by a year. On the other hand, the model's charm may have prompted Larsson to invite him to Sundborn to pose again the following year.*

68
Birches by a Brook 1894
pencil, ink, and wash on paper
34.0 x 22.5 (13⅜ x 8⅞)
[Nationalmuseum, Stockholm, Sweden]

This drawing, done at Husqvarna, was made as a study for the Singoalla *illustrations.*

70

The Library at Drottningholm Castle *circa* 1895
pencil and watercolor on paper
50.6 x 33.4 (20 x 13⅛)
[Nationalmuseum, Stockholm, Sweden]

Illustrated, with commentary, on p. 29.

69

A Sunday at Djurgården *circa* 1895
ink and wash on paper
40.0 x 30.0 (15¾ x 11¾)
[Nationalmuseum, Stockholm, Sweden]

*Done for a weekly illustrated magazine, this drawing creates
the illusion of a group of snapshots casually pinned to a wall.
Although the format of combining several sketches into one
design was typical of the period, the tonality and informal
composition of these images recall the fact that since the
invention of Kodak roll film in 1888 amateur photography
had become an increasingly popular pastime. A typical Larsson
touch is the little Punch-and-Judy and golliwog group that
comes out of a jack-in-the-box to push aside the image at the
center right. The vignettes are all from Stockholm's Royal
Djurgården park, which then as now was a popular area for a
Sunday outing.*

71

Study for Lovisa Ulrika 1895
charcoal and pastel on paper
62.2 x 47.6 (24½ x 18¾)
[Nationalmuseum, Stockholm, Sweden]

*This drawing for the Nationalmuseum fresco (see illustration
on p. 31) concentrates upon the drapery and details of the
Queen's dress, which becomes even more voluminous and
elaborate in the final version. Larsson's pleasure in detailing
costume, in particular the folds and billows of dresses, can be
seen frequently in the Sundborn watercolors.*

72
"Beau" Rosen *circa* 1895
charcoal on paper
36.6 x 48.6 (14⅜ x 19⅛)
[Nationalmuseum, Stockholm, Sweden]

This close-up study of a man's head is for the figure of the sculptor Johan Tobias Sergel in the Nationalmuseum fresco (see p. 30). The man posing was a well-known model of the period.

73
Rococo Model 1897
charcoal on paper
65.0 x 50.0 (25⅝ x 19¾)
[Private Collection, Sweden]

This drawing, which may be a study for the Royal Opera House decorations that Larsson made in 1897, again shows his interest in the flow and modelling of drapery.

74
Study of Children and a Flowering Branch n.d.
pencil and watercolor on paper
26.5 x 21.0 (10⅜ x 8⅛)
[Nationalmuseum, Stockholm, Sweden]

The date of this drawing is either 1894, when Lisbeth was three years old and Brita one, or 1897, when Brita and Kersti were the same respective ages. It must have been from many quick studies of this kind that Larsson developed the repertory of childrens' figures which he used in the finished watercolors.

78
Flower Study *circa* 1908
pencil on paper
26.4 x 20.6 (10⅜ x 8⅛)
[Nationalmuseum, Stockholm, Sweden]

At his best Larsson was able to draw flowers with a distinctive combination of descriptive accuracy and decorative line. Such a study as this one should probably be dated to 1908-09, when he was working on the watercolors for Åt solsidan, *in which there are a number of garden settings.*

75
Karin and Kersti 1904
pencil on paper
26.5 x 18.8 (10⅜ x 7¾)
[Göteborgs Konstmuseum, Sweden]

The popularity of Larsson's domestic subjects led him to make a number of etchings on these themes. This drawing of Karin combing her youngest daughter's hair while Kersti draws was made in preparation for the etching which follows (cat. no. 76).

76
Karin and Kersti 1904
etching on paper
26.7 x 18.2 (10½ x 7⅛)
[Göteborgs Konstmuseum, Sweden]·

The etching is marked in the plate, in Swedish, "First Impression."

77
Girl with a Flower Garland *circa* 1904
charcoal and watercolor on paper
61.5 x 45.0 (24¼ x 17¾)
[Nationalmuseum, Stockholm, Sweden]

Illustrated, with commentary, on p. 32.

The following drawings were made as vignettes for the texts of Larsson's books, all of which were first published by Bonniers in Stockholm [Albert Bonniers Förlag AB, Stockholm, Sweden].

De mina, 1895 (cat. nos. 79-80)

The first edition of *De mina* included only one watercolor, which was used as a frontispiece. There were, however, drawings in the text, and they were often humorous.

79
The Goblin's Awful Revenge
ink and wash on paper
20.0 x 16.0 (7⅞ x 6¼)

80
Picture-Wall
ink on paper
9.0 x 20.0 (3½ x 7⅞)

Ett hem, 1899 (cat. nos. 81-83)
81
Suzanne, Ulf, Pontus, Lisbeth June 1891
ink on paper
46.5 x 29.0 (18⅛ x 11⅜)
Illustrated, with commentary, on p. 34.

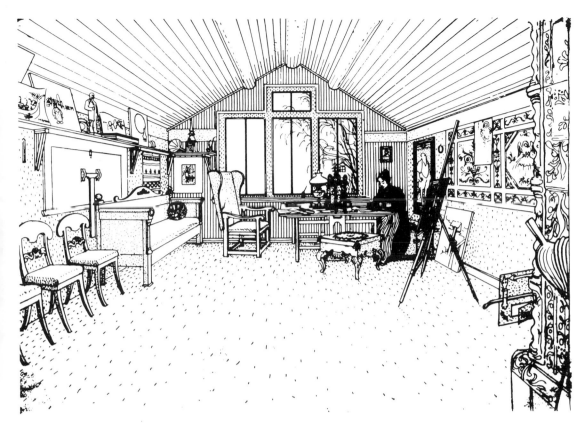

82
Karin in the Studio
ink on paper
31.5 x 46.0 (12⅜ x 18⅛)

Illustrated above.

83
Holiday Reading
ink on paper
31.5 x 46.5 (12⅜ x 18⅛)

Illustrated below.

The two boys, Ulf and Pontus, are seated at the same sitting room window seen in cat. no. 14, p. 57.

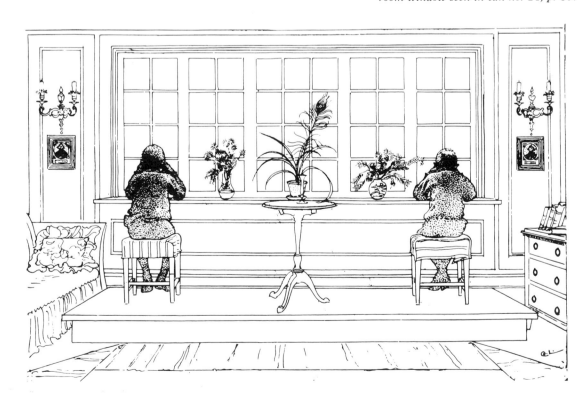

Àt solsidan, 1910 (cat. nos. 84-89)

The vignettes from *Àt solsidan* are drawn with a thick decorative black line akin to that seen in the many book plate designs published in *The Studio*. This selection includes some of the few drawings of urban industrial subjects in Larsson's oeuvre.

84
The Tarn
ink on paper
19.0 x 11.5 (7½ x 4½)
Illustrated on p. 47.

85
On the Other Side
ink on paper
17.0 x 11.5 (6⅝ x 4½)
Illustrated on p. 41.
The Sundborn house is seen across the water at left.

86
The Gate
ink on paper
19.0 x 11.5 (7½ x 4½)
Illustrated on p. 66.

87
Dressing the Ore—Falun
ink on paper
18.0 x 11.5 (7⅛ x 4½)
Illustrated on p. 95.

88
My Street
ink on paper
19.0 x 11.5 (7½ x 4½)
Illustrated on page 9.

89
Slagheap—Falun
ink on paper
19.0 x 11.5 (7½ x 4½)
Illustrated on p. 95.

92
Poppy
ink on paper
6.0 x 35.0 (2¾ x 13⅝)
Illustrated on p. 67.

93
Lilac
ink on paper
6.0 x 35.0 (2¾ x 13⅝)
Illustrated on p. 5.

94
Birch
ink on paper
6.0 x 35.0 (2¾ x 13⅝)
Illustrated on p. 51.

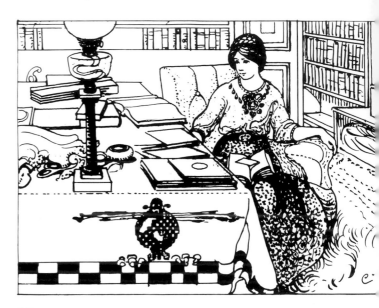

95
Girl at a Table
ink on paper
15.5 x 21.0 (6⅛ x 8¼)

Andras barn, 1913 (cat. nos. 90-95)

In this book are published a number of the portraits that Larsson made of his friends' children and his own grandchildren. The text includes many informal portrait vignettes, and horizontal bands of flower and plant motifs are printed at the top of each page.

90
Wild Rose
ink on paper
6.0 x 35.0 (2¾ x 13⅝)
Illustrated on p. 38.

91
Queen Anne's Lace
ink on paper
6.0 x 35.0 (2¾ x 13⅝)
Illustrated on p. 96.

Cat. no. 87

1895, *De mina (My Family)*, Stockholm, Albert Bonniers
Förlag.

1899, *Ett hem (A Home)*, Stockholm, Albert Bonniers
Förlag, 24 plates with text and vignettes.

1902, *Larssons (Larsson's)*, Stockholm, Albert Bonniers
Förlag, 32 plates with text and vignettes.

1906, *Spadarvet (My Little Farm)*, Stockholm, Albert
Bonniers Förlag, 24 plates with text and vignettes.

1907, *Svenska kvinnan genom seklen (Swedish Women
Through the Centuries)*, July 1907 number of *Idun*.

1910, *Åt solsidan (On the Sunny Side)*, Stockholm, Albert
Bonniers Förlag, 32 plates with text and vignettes.

1913, *Andras Barn (Other People's Children)*, Stockholm,
Albert Bonniers Förlag, 32 plates with text and vignettes.

1931, *Jag (I)*, Stockholm, Albert Bonniers Förlag.

Cat. no. 89

Harriet and Sven Alfons, *Carl Larsson skildrad av honom
själv* (Stockholm: Albert Bonniers Förlag, 1977).

Axel Frieberg, *Karin. En bok om Carl Larssons husfru*
(Stockholm, 1967).

Gothenburg, Gothenburg Art Gallery, *Carl Larsson*,
introduction by Eva von Zweigbergk, 1971.

Ulf Hård af Segerstad, *Carl Larsson's Home* (Reading,
Mass: Addison Wesley Publishing Co., 1978).

Helsinki, Amos Anderson Art Museum, *Carl Larsson
1853-1919*, 1981.

John Kruse, *Karl Larsson som målare, tecknare och grafiker*
(Stockholm: Albert Bonniers Forlag, 1906).

Bo Lindwall, *Carl Larsson och Nationalmuseum* (Stockholm:
Rabén and Sjögren, 1969).

Ernst Malmberg, *Larsson, Liljefors, Zorn, en återblick*
(Stockholm, 1919).

George Nordensvan, *Carl Larsson* (Stockholm, 1902).

—— "Carl Larsson," *Sveriges Allmänna Konstförenings*,
del. 1-2, publ. XXIX-XXX (Stockholm, 1920-21).

Axel L. Romdahl, "Carl Larsson, som etsare," *Sveriges
Allmänna Konstförenings*, publ. XXI (Stockholm, 1913).

Stockholm, Liljevalchs Konsthall, *Carl Larsson
minnesutställning*, by Bo Lindwall, 1953.

Eva von Zweigbergk, *Hemma hos Carl Larsson* (Stockholm:
Albert Bonniers Förlag, 1968).

Index to Lenders

Catalogue numbers in bold indicate that the work is reproduced in color.

Ragnad and Birgit Åhléns Foundation, Falun, Sweden: 50.
Mr. and Mrs. Arthur G. Altschul, New York: **35**, **39**, **41**.
The Art Institute of Chicago, Illinois: 28.
The Art Museum of the Atheneum, Helsinki, Finland: 22, 24, 32, 36.
Albert Bonniers Förlag AB, Stockholm, Sweden: 79, 80, 81, 82, 83, 84, 85, 86, 87, 88, 89, 90, 91, 92, 93, 94, 95.
Prins Eugens Waldemarsudde, Stockholm, Sweden: 6, 8, 31.
Falun Municipality, Sweden: 52, 53.
Göteborgs Konstmuseum, Sweden: 11, 21, 33, 65, 66, 67, 75, 76.
The Helsingborg Museum, Sweden: 34, 46, **51**.
The Malmö Museum, Sweden: 37, **38**, 48.
Nationalmuseum, Stockholm, Sweden: 1, 2, 3, **12**, **13**, **14**, **15**, **16**, **17**, 18, 19, **20**, 25, 26, 30, 55, 56, 57, 58, 59, 60, 61, 62, 63, 64, 68, 69, 70, 71, 72, 74, 77, 78.
National Portrait Gallery of Sweden, Gripsholm Castle: 9, 10.
Private collection, Finland: 49.
Private collection, Minneapolis, Minnesota: 5.
Private collections, Sweden: 4, **7**, 27, **29**, **40**, **43**, **45**, **47**, 54, 73.
Sundborn, Carl Larsson-Gården, Sweden: 44.
Turku Art Museum, Finland: 42.
The Zorn Museum, Mora, Sweden: 23.

Cat. no. 91